REFUGEE TALES

VOLUME V

EDITED BY
DAVID HERD & ANNA PINCUS

First published in Great Britain in 2024 by Comma Press.
www.commapress.co.uk

Copyright © remains with the authors, editors, translators and Comma Press, 2024
All rights reserved.

The moral rights of the authors to be identified as the author of this Work have been asserted in accordance with the Copyright Designs and Patents Act 1988.

A CIP catalogue record of this book is available from the British Library.

ISBN-10: 1912697904
ISBN-13: 978-1912697908

Proceeds from this book go to the following two charities:
Gatwick Detainees Welfare Group and Kent Refugee Help.

The publisher gratefully acknowledges the support of Arts Council England.

Printed and bound in England by Clays Ltd, Elcograf S.p.A

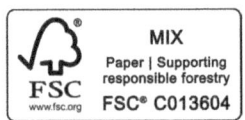

Contents

PROLOGUE	vii
THE HOST'S TALE as told to Tessa McWatt	1
THE DRESSMAKER'S TALE as told to David Mitchell	11
THE SELF-ADVOCATE'S TALE as told by Pious Keku	21
THE THIRTEEN YEAR TALE as told to Hannah Lowe	31
THE PATIENT'S TALE as told to Natasha Brown	41
THE LEADER'S TALE as told by Osman Salih	45
THE DISSENTER'S TALE as told to Daljit Nagra	59
THE BUSINESSMAN'S TALE as told to Haifa Zangana	65
THE FRIEND'S TALE as told by Ridy Wasolua	73

CONTENTS

THE YOUNG MAN'S TALE as told to David Flusfeder	89
THE HUMAN RIGHTS DEFENDER'S TALE as told by JB	101
THE CORRESPONDENT'S TALE as told to Scarlett Thomas	111
THE LISTENER'S TALE as told to Shamshad Khan	119
THE STRANGER'S TALE as told by Raga Gibreel	133
THE FOOTBALLER'S TALE as told to Guy Gunaratne	139
THE CAMPAIGNER'S TALE as told by Seth Kaitey	147
Afterword David Herd	149
About the Contributors	165
Acknowledgements	170

Prologue

Whereas
Lilac
Bloomed
Against the billboards
Albeit torn
Besides the building
Where the sun
Broke in

And whereas people
And all the talk
And all the gatherings
Towards equality
And the rose
And the wood pigeon
Against an open field

And whereas
The distance
Which we would collapse
Into intimacy
Broken against the language
Of a difficult day

PROLOGUE

And whereas
The heart
Gave out
And whereas
We repudiated
The nation
And it was warm
And against the narrative
People articulated
Their way

And whereas
It was not so much
And since
Nobody thought
That it was sovereign
Like the wisteria didn't
Or the people
Since this was time
To walk

Start out
Against the ground.
And whereas people
Being people
Where the goldfinch
Against the backdrop
Where the silence
Stalks

And whereas
The state
And whereas the mechanism
Was arbitrary
Where the heart

PROLOGUE

And where the lungs
And whereas the stamina
Gave way
Where people walked
Against that fact
And whereas the language
Relented
Briefly
Against the building
Where the lilac
Lay

Where the geography
Held good
Where it was that nobody
Reported
Where we sat
Unbeknownst to anybody
Against an open field
That day
You spoke
And whereas everything
In abeyance
State
Lilac
We heard the language
Yield.

The Host's Tale

as told to
Tessa McWatt

ASSEEDA, TAGALIA, GORAASA, KAJAIK. I practice saying the names of these foods so that I will not appear ignorant for our meeting. I arrive early to the restaurant on Edgware Road. The server greets me. She is wearing a Sudanese toub: her head covered; her eyes bright. I ask her for a menu, but she hesitates. Only after she lays it on the table do I realise the source of her hesitation: the menu is in Arabic. I tell her that I'm waiting for someone who will know how to order for us. She smiles, 'Yes, good, he will,' she says. Asseeda, tagalia, goraasa, kajaik, I say silently.

I have a few minutes before Y arrives, so I check the news on my phone. More than twenty days into the Russian invasion of Ukraine. The resistance continues: *The Ukrainian army has killed another Russian general. But, as the United Nations confirms, more than three million people have fled the country.* I click out of the news, quickly, and get ready to record my conversation with Y, whom I see crossing the road. He enters the restaurant and his bright orange jumper and cheerful face make me smile. He has given a lift to this grey west London day with news of war, the ongoing pandemic and our climate crisis.

Y left West Sudan in 2016, when he was 19 years old, to escape racial persecution. His family are from a small town near Khartoum, where the Blue Nile and the White Nile converge, bringing people from many parts of Africa. Moving from his hometown to the capital, he sought to build a more prosperous future for himself, but he experienced the racism of the Arabic tribes – who hold power in the country – towards the subordinated African tribes. There, if you are from one of the African tribes, he told me the first time we met, they treat you 'like a slave… they look at you as though you are not a human being.'

A few months into working in Khartoum, he was arrested and wrongly accused of supporting rebels who were calling for the removal from office of Omar al-Bashir, the authoritarian president. Y's employer was a man involved with the rebels, and through this association Y was detained and questioned about rebel activity. He was taken to prison, where he endured abuse and torture over the course of a month. His captors pressed him for information on the source of the rebels' finances, of which he knew nothing, but they continued to torture him. For three days he had no food or water. 'It was like death,' he told me.

Finally, towards the end of the month and his ability to endure 'this death', he falsely promised them that he would bring them information. They forced him to sign a letter admitting to his guilt by association, and then allowed him to leave prison under the condition that he provide them with what they had asked for. He consulted with a friend, a solicitor, about what he should do. He was advised to flee. There was no hope for anyone who had an issue with the government. No trial, no judge, no chance for justice. He had no choice.

Y was smuggled from Sudan to Libya in a 4x4 jeep through the desert. Fifteen men in one vehicle, and three days through the desert to the mountains, where they were finally

THE HOST'S TALE

deposited in Kufra, and where the smugglers demanded $2000 from each of them. Some of the men were able to pay, but Y was not. He was sold to another smuggler who took him to Tripoli, where he was forced to work off his debt by making bricks in a factory. Not allowed to leave the factory premises, he worked, ate and slept in the factory compound, along with Cameroonians, Chadians, Egyptians and other Sudanese – 'a miniature African continent' – who were all working to pay off their debt to smugglers.

His existence for a whole year was comprised of working without pay, making blocks, living and eating in a small factory where some of the men, who had become ill, who had been deprived of anything humane, died right in front of him. One day it was all too much. He knew that if he was going to die he would prefer to go back to Sudan. He refused to work. 'If you want to kill me, kill me, I will not do anymore,' he told the smuggler. Afraid that Y's attitude would spark a rebellion among the others, the smuggler offered to send him to Europe.

'Welcome, Tessa,' Y says as he now takes his seat at the table at the Sudanese restaurant.

'I'm hungry,' I say, 'for something other than oily potatoes!'

He laughs. It's a joke between us from the first time we met at the British Library, where the idea for meeting at this restaurant first arose. Oily potatoes were a recurring image in his recounting of his time in England so far. We spoke a lot about food, about what he was given the moment he arrived in the UK – hot chocolate – and what he eats now at the hotel in Hounslow where he's housed among other asylum seekers. The cooks know him after all this time, and they leave out the oily potatoes from his servings, offering him plain pasta instead.

Y speaks to the waitress to let her know I haven't had Sudanese food before. He turns his attention back to our conversation, and I learn that there aren't a lot of Sudanese

restaurants in London because many migrants from Sudan are professionals and have a different attitude to working in a restaurant, which they don't see as a job. If they are eating Sudanese food they are at home, celebrating or sharing food with friends and family. Y's father, who sells tobacco and coffee beans, wants him to be a professional – 'a doctor or something nice' – but Y says he wants a simple, good life. He would do a professional job, but he thinks he might like to be a chef. Maybe he will open a restaurant. He describes the hospitality of Sudanese people: everyone eating together, meals shared with all, and the fact that strangers and foreigners are welcome. In contrast, at the hotel in Hounslow he cannot share food with the other asylum seekers waiting for their papers. He has to take his food to his room to eat alone. He doesn't understand how people don't get sick from the food he has been offered while waiting for his claim to be processed. He visits friends, when he can, and together they eat Sudanese food – the traditional aseeda, tagalia or goraasa. 'If you eat the food they give you in detention – so oily – maybe you will lose your health,' he says.

He orders for us and soon we are served goraasa, a doughy flatbread enveloping stewed meat. We tear off sections to eat with our hands.

His intention was never to come to Europe but simply to escape Sudan. He thought Libya would be better, but it was worse, and now he was headed to Europe via Libyan smugglers. He arrived by boat in Lampedusa and was forced – beaten – into being fingerprinted in order to be fed and given shelter. After three weeks in the camp, he learned of a friend who had been sent back to Sudan by the Italian government and had not been heard of since. Fearing for his own safety, Y fled Italy and found his way to the coast, then onto a train from Ventimiglia to Marseille. A French family hid him under the seats of their compartment as they crossed the border into

THE HOST'S TALE

France. It felt like a relief, but only briefly.

Now a tall young man enters the restaurant, and we are interrupted as he approaches Y, who stands to greet him. They tap shoulders, then what would normally be a handshake is a wrist pump because Y is in the middle of eating. Y introduces me to the man, and I do a similar wrist pump. While Y talks him, I glance at the news on my phone again: *A Nigerian man trying to get into Poland from Ukraine said border staff told him they were 'not tending to Africans.' 'We've been chased back, we've been hit with police armed with sticks,' he told the BBC. There have also been numerous reports of Ukrainian security officials preventing Africans from catching buses and trains going to the border.*

When Y sits back down, he tells me that he met this tall man in Calais, when he was first sent there after his asylum claim had been rejected because he had been fingerprinted in Italy and not France. In the Calais jungle, he says, 'we lived together like brothers,' eating together, keeping one another alive.

In the jungle, desperate not to be returned to Italy and in all likelihood Sudan, Y joined 11 other men who planned to get to the UK. They acquired an inflatable dinghy and paid for a motor that was brought to them by the French girlfriend of one of the men. On a pre-dawn morning, while the first Covid-19 lockdown was still in place, the 12 men took off in darkness towards Dover, with only one man – who had a heart problem – wearing a lifejacket.

After an hour on the channel, the dinghy began to lose air, and at times its edges tipped below the surface of the water, which started to fill the floor of the boat. Their only bailing tool was a small cup, which they filled and emptied, filled and emptied at the greatest possible speed. The man in the life jacket became ill. Towards the fourth hour on the water, as the sun rose on the horizon and the water rose towards their legs, they became desperate, and one of the men called the Border Force. 'Au Secour!' they yelled, afraid the dinghy would soon

be flat. Y was in disbelief – would all he had gone through end here, by drowning in the channel? Because he could speak French and a bit of English, he was able to speak to the border police and describe what was happening to them. They were rescued, none of them ending up in the water, but the man in the life jacket died soon after they landed.

The British Border Force took them to Dover for two days and then to the same hotel where he is now. Hot chocolate. Fish and chips. After two days he was moved to a hotel in York. With the Covid lockdown closing most hotels, but opening some for unhoused people and asylum seekers, the hotel Y stayed in was a refuge, where the staff were paid by the government to look after their asylum guests, where the hospitality of a hotel was offered to the over 100 refugees in their own rooms. While they weren't allowed to eat together due to the Covid restrictions, refugees were asked what kind of food they wanted. The other refugees were kind, good natured. This place was welcoming, not hostile.

But, as we now know, lockdown kindnesses were exceptions to 'normal.' And they were fleeting. After six months, when funding for this hospitality ran out, Y was moved to accommodation in another northern city, a shared house, where he was told he would be allowed to apply for asylum. Two weeks later, however, the Home Office came to take him to a detention centre. Because he had been fingerprinted in a country before he arrived in the UK, Y was now being threatened with deportation.

After one day in prison, he was taken to Brook House detention centre near Gatwick. He was in despair. Many of the people around him had given up; some had severe mental illness; a few tried to die by suicide.

We sit in silence for a few minutes before I try to break the mood. When I ask him what they fed him, he smiles. Oily potatoes. But then he gets serious again: 'I cannot say it's rubbish, because it's a blessing,' he says, but he adds that he

doesn't think I'd like them either.

Detention was like jail. A mattress, a small toilet in the corner. A TV. Small windows in the doors allowed him to see the men – some in uniform, others being brought to stay -- walking past his room. 'Some people think the UK is a heaven,' he says, 'I want people to know that we do not come here without giving up so much at home; we come here because we have no choice.' At 9pm in detention they lock the doors. In the night there are prolonged screams from those who are being taken away for deportation.

'Life is still life,' Y says.

When Y's lawyer listened to the details of his journey and understood that he'd been trafficked in Libya, a small window of hope opened. This would be the foundation of his case to remain in the UK, and finally Y was released from detention and moved to this current hotel, a temporary stop until he hears from the Home Office.

He has been waiting to hear from the Home Office for nearly two years.

Lockdown compassion has disappeared behind the primacy of market forces. The hotel in Hounslow has opened up, 'post-Covid,' and has welcomed travellers from all over the world, but the hospitality towards refugees has been curtailed. Y sometimes thinks he won't get to stay.

'And what would you like to do if you stay?' I ask.

'I would like to work in immigration, to help other people,' he says. 'Or in another charity, the best way to learn English.'

'And cook?'

'Yes, I'm a good cook,' he says.

'Why do you want me to tell your story?' I ask.

'My idea likes yours,' he says. 'People think that refugees come here just to steal jobs, but they would not come if they did not have a really strong reason to risk life. What you do for me is really something great. And if you are really honest with

what you do, believe me, it helps.'

The tall man who greeted us with the tapping of wrists walks past our table and waves to us: a goodbye with great warmth.

Our dessert arrives – pastries with pistachio and honey – and I ask Y a few more personal questions. He hopes to lead a normal life. If he lives in a small room and he's free, that's all he wants. He has qualifications in management and worked for a year with the Red Cross. He would like to do something similar here. One of his Calais brothers who also came by boat has already got his settlement papers, and Y came three months before him. There doesn't seem to be a system that's fair, he says. A lot of migrants are qualified and really want to give back. He shakes his head but smiles.

'You smile even at things that are difficult,' I say.

'If I can compare Sudan and the UK, there is a very different way to welcome.'

He tells me that due to the position of Sudan in Africa there are many people who go through it to get to Libya and Egypt. 'We have a lot of refugees in Sudan,' he says. 'We don't think they come to take our life. If you come you will be welcome. If you can't buy water, I will pay. If your car breaks down, you can stay with me for as long as you need. We welcome foreigners.'

When I ask him about racism in the UK, he admits that sometimes he's abused. A few people in the parking lot of his hotel in York accosted him while he was getting some air. They filmed him trying to defend himself. He thinks it's silly to think about differences in skin colour. In London things are better, but he doesn't feel he belongs in a big city. He'd like to live in a smaller place. He loves to do sports, loves to be outside.

'I hope Putin will not finish everything,' he says. We sit in silence again.

I think about all that Y's asylum claim rests on – a willing

THE HOST'S TALE

Home Office, the right timing. And perhaps a more unspoken kind of fortune. In more news today: *An 11-year-old Ukrainian boy was treated to a hero's welcome in Slovakia this week when he crossed the border after travelling 1,000 kilometres alone, fleeing the war with Russia. His mother had sent him to safety, unable to leave herself.* 'The boy came all alone with a plastic bag, passport and a telephone number written on his hand,' the Slovak Embassy in the U.K. said. *Officials praised him for 'his smile, fearlessness and determination of a real hero.'*

I think about the common root of 'host' in the words hospitality and hostility – from the Latin, *hostis,* for foreigner, stranger or enemy. And I wonder when and why one becomes the other.

While Y finishes his coffee, I get up to pay the bill for our lunch. The waitress who greeted me tells me that 'the man already paid it.' I'm bewildered, embarrassed, wondering if Y confused my invitation to lunch with a request for him to host me for Sudanese food. I ask the waitress if there could be a mistake. She assures me that the bill has been paid.

When I return to the table I chastise Y for taking care of the bill, when it should have been my offering, as gratitude for his story. He looks surprised. He didn't pay, he says, and I tell him what the waitress said. He gets up immediately to talk to her, and they have an in-depth conversation in Arabic. He comes back to the table. I wait for his explanation.

'My friend paid the bill,' he says, without ceremony.

For a moment I am confused, but then I realise that he means the friend who wrist bumped us. The man with whom Y shared food and sleep and anger and hope in the Calais jungle paid for our lunch.

It takes me a few minutes to process all my conflicting thoughts. I stop the recording on my phone. I have no impulse to check the latest news, but I think about the two years since Y arrived on the sinking dinghy. I must conjure words that will describe the experience of hearing his story – the etymologies

of hostile and hospitality, of stranger and estranged.

It dawns on me that the word home is better described as an action. Something to make, something to give. Something to establish, to make available. An act of decency.

The Dressmaker's Tale

as told to
David Mitchell

MY FATHER WAS A prince from Nigeria. That sounds strange to you, I guess. But in Nigeria there are many royal families. Many. 'Ruling families' they are called also. Nobody knows how many there are. Hundreds, for sure. Princes are more common in Africa than in England and Europe. But to be a prince is still a big deal. My father's family was rich enough to send him to college in London. During this time he met my mother, and I was born in 1966. I have my UK birth certificate. Look. It is important for what is to follow... See? Born in the UK. You can see my name. But I prefer that you do not name people in my story. Many are still alive. Giving names might make trouble for them or for me.

When I was very little, I was taken to Nigeria and I never saw my mother again. So, I have no memories of her. Not her face. Nor her name. I don't have any memories of her. I know she was a black woman, but that was all. Sometimes when I think about our separation when I was so young, the pain is very great. Even today, I shed tears. Was she forced to give me away? Was she deceived? Did she know I was to be taken to Nigeria? I don't know and I cannot find out the truth. I bear

the pain, because what choice do I have? But the pain never leaves me. When I became a mother, I transferred my mother's love for me to my own children. That is how I try to turn my pain into a kind of joy.

Because I was so young when I left England, my first memories are of my father's house. A big house in Ebute Metta, an area of Lagos. 'A palace fit for a king.' It has different rooms and quarters. A courtyard. A big fence around it. It was always crowded with relatives and people wanting my grandmother's help. More than the other women in that house, it was my grandmother who raised me. I loved her and she loved me. Some people in the community even gossiped I was my grandmother's final child! Ah, people love to gossip.

When you come from a polygamous house, you see a lot of things. A *lot* of things! I grew up in the middle of a family war. My father's wives were not good to me. They told their children not to talk to me. When my grandmother was not there, they smacked me. Slapped me. Hit me. But I did not cry. I just took it as my luck for that day. Those women did not know it, but they were making me stronger. They were cruel, but their cruelty taught me to be an independent woman. To this day, I do not rely on anyone else.

When I was a girl, I was the black sheep of the family. But I did not choose to be the black sheep. I did not know why I *was* the black sheep. I thought maybe the others treated me badly because my grandmother loved me more. Nobody told me about my mother. As if the subject was shameful. As if I was shameful. And I accepted this as normal.

My father? He was too busy to bother himself with his motherless daughter. Every time he came to the house – his own house – he brought a new girlfriend with him. Always another woman. I think he did so to send a message to his other wives: *See? I don't need you. You're not so special.* This was his plan, his plot, to make his wives jealous. To make them fight

between themselves, to prove that *they* were the Number One Wife, not the others.

Only when I was around twelve did I ask, 'Hey, what is going on here? What is wrong with you all? Why do you hate me so much?' By asking these questions until I broke through the taboo, I learned that my mother was a Trinidadian woman. Not Nigerian. Not West African. Probably I would never see her. Finding this out made me sad. But at least now I knew. And *I* didn't feel ashamed of her.

I had no way of contacting my mother. This was still the 1970s, remember. So in a way, my grandmother took on the role of my mother. She was a female politician in Lagos. A real boss! That is what she is. Strong, strong, strong. That lady was my angel. My role model – as a woman, as a mother. Even now, I emulate her in everything I do. Only one thing I didn't take from her... can you guess? The desire to be a politician. Once I was asked by a new party if I wanted to walk in my grandmother's footsteps. I said, 'I'm sorry but I'm not interested...' If I said yes, my life would have been different. Very different.

My grandmother had to be away from our house a lot, doing her job, meeting people, arranging deals. And when she was out, like I told you, I was subject to punishment from the other wives. Luckily, around this time, I went to boarding school. Sometimes my classmates complained about the school, or lessons, or small things. Not me. At school, I had friends. I was free. When I had to go home for the holidays, it did not feel like home. I stayed in my room as much as possible. The other children – my own cousins – still did not speak to me. Because their mothers ordered them.

When I was 15, my father gave me a picture of my mother. Such a wonderful moment! Like a dream. Photographs were rare and precious in those days. Straight away, it became my most precious possession. But then my uncle came to me and said, 'Lend me that photo, so I can enlarge it, and then you can

see your mother properly.' So I agreed. And I gave him the photo. And guess what. I never saw the photograph again. There were no copies. It was gone. Gone.

When I asked my uncle, 'How could you do such a thing?' and 'Why do you not want me to have a picture of my own mother?' he refused to answer. He looked away. As if my questions did not exist. As if I did not exist.

My mother's face from the lost photograph faded from my own memory. Later, when I returned to the UK in 2000, I searched for her on the internet. By now I knew my mother's family name, at least. Maybe I could find relations who shared the same surname. I never did. I am still looking. My mother will be an old woman now, if she is still alive. Does she ever think of me? When I think these thoughts, it is easy to fall into anger and despair. But there is nothing I can do. Nothing.

I was seventeen when my grandmother died. My protector was gone. So I moved in with my auntie – brother's younger sister – in a different part of Lagos. Overnight my life got better. My cousins were kind to me. We became friends. I am close with them, even today. Sometimes my father visited me at school, to see how I was. He gave me things I needed. Perhaps he felt guilty about my mother. I do not know for sure. He didn't speak about his emotions much. And I could not see inside his head.

After I finished school, I had to consider my future. If you don't have anyone to help you, you have to help yourself. So I studied fashion design and dressmaking. This allowed me to make my own money. Also, I took a course in catering and hotel management. But I like making clothes best of all. I like to choose the material and select a design. I have the measurements of the customer, I have my sewing machine. Then I get to work, and a few hours later, I have a finished dress or blouse and a happy customer. This work is satisfying. I am a good seamstress. Here is my sewing machine, see? This is not the professional one I used to own... A charity here in

England got me this. When I am tense, I like to make something, or write, or paint… Here are my paintings. A woman on a beach. These birds. Making art calms me. You see? This one, this mosaic, I haven't finished…

When I was 24, my auntie wanted me to marry a man. I did not even know him. I did not want to marry him. So we had a big row. In the end I told her, 'Sorry, Auntie, but I cannot marry this stranger.'

So my auntie said, 'Then you have to move out.' And that is what I did. Maybe I could have resolved the situation, but it was time to leave her house. I am grateful to my auntie for sheltering me after my grandmother died. I did not want us to become enemies.

I moved into an apartment which I had on my own. I had to survive as a single woman making her way in Lagos. I worked as a dressmaker. I worked as a chef. I had many experiences. I became rich in experience! I went through the thick, high, hot, cold of life. I know what life is. I know what I've been through. And I thank God for giving me the strength to pass through it.

My father died. My feelings were complicated. As his daughter, I felt grief. I felt some despair. My hopes of learning who my mother was died with my father. So I felt anger also. But I had no place to put this anger.

After some years, I got married to a man of my own choice. We had three beautiful children. They are a blessing from God. I do not want to talk about my husband. This story is not about him. I will say only that he was frustrated he could not control me. I was making my own money, you see. A man cannot control a woman he does not feed. He had no authority over an independent woman. In Nigeria, in other countries also, this is a problem for a man. So my husband did not support my work. But at the same time, he expected *me* to bankroll him. We stayed together, but it was a difficult situation.

Now I must tell you about my father's friends who lived in England. Sometimes these friends visited Nigeria, and came to my father's house when I was growing up. My father liked to introduce me to them, perhaps because I was British and Nigerian. Perhaps he was a little proud of this and liked to show me off, you know? Whatever the reason, my father's wives did not like this.

One of my father's friends was a medical doctor in the NHS in England, in the county of Norfolk. In the late 1990s he saw how I was living with my husband and children in Lagos and said, 'If you go to the UK, earn money there and send it back to Nigeria, you could earn enough money to give your children a proper education. If you stay here, you cannot.' At first, I was not sure. Going to the UK was a big step. Where do I live? How do I find a job?

But the doctor said, 'Your father was my good friend, so for his sake I will help you.' And he did what he promised. Using my birth certificate, he helped me apply for my British passport and my visa. And in 2000, I left my children with my father's family and flew to the UK. For the first time in over 30 years, I was back in the country where I was born.

England was cold and rainy and grey and not so friendly. It was difficult to leave my children in Lagos, but their future mattered most. Most parents can understand this, I think. I came to the UK to work so their futures would be better. Everyone knows what conditions are like in Nigeria. The government will do nothing for you. Nothing.

The doctor lived in Norwich. In return for working as his part-time housekeeper, I lived in a small flat in his house. I began to make dresses, on a small scale. One time I went to Liverpool to buy material. By chance, I met a Nigerian lady who had a clothes business. We became friends. She was impressed with my dressmaking skills. She gave me orders. I went back to Norwich, made the clothes, then brought the

THE DRESSMAKER'S TALE

clothes back to her to sell. When they were sold, she paid me. It was a good arrangement. I sent money back to Nigeria to pay for my children's education.

One day in 2009, I was on the phone to my children back home. The doctor came in and he said, 'You are spending too much time talking to those children – you should spend your energy on me.'

I said, 'What do you mean? I have prepared your food. I keep your house clean. What else is it you want?'

He said, 'Okay, do you think I brought you to the UK for nothing?'

I said, 'What are you saying?' And he answered that he wants me to become his mistress. I told him 'No way'. That was not possible. I would not be anybody's mistress. He was my father's age.

The doctor said said, 'Okay, if you can't be my mistress, move out of my house.'

So I moved out. I survived like before, by working. This is important to me. I never asked the government for help. I made clothes. I did hairdressing. I did a lot of things. In 2012, I moved to Oxford. There I worked for Carillion. I was a chef for a while. A housekeeper. I worked for the council. Back in Nigeria, my children were growing up. I was able to pay for their college. Things were going well. Then, on September 15th 2017, my life changed.

I was waiting at the bus stop to go home. A police van pulled up. Two uniformed officers got out. They asked me my name. So I told them. I had nothing to hide. They said they had been looking for me. I said, 'What for?' They said they won't explain on the street – they will only explain at the police station. So I had to go with them. At the station they asked me my address. Of course, I told them. They asked for the key to my flat. I thought, 'I have no skeletons in my cupboard,' so I gave them my key. I thought this was the quickest way for them to understand they had made a mistake.

An officer took my key and went away. Like the photograph of my mother, I did not see that key again.

Next, a police officer took my fingerprints. Now I asked, 'Officer, what do you think is my offence?' An officer said I had committed fraud. I said, 'No no no, you are mistaken – what fraud are you talking about?' The officer said I had committed fraud at my job. I said, 'But this makes no sense. Everything I order at work is ordered online. My supervisor can see what I order. Even if I wanted to commit fraud, it is not possible.' The officer searched my bag. Now I was worried. I could not understand what was happening. A nightmare began. I am still inside this nightmare.

I had to stay at the police station for six days. At some point, a solicitor came to interview me. On Monday I was taken to court. From the court, I was taken to HM Eastwood Prison.

That place is a terrible place. I was not allowed go back to my flat, not once. The police said I would try to disappear before my trial. My trial for what crime? I couldn't understand. Now they said my fingerprints matched the fingerprints of a criminal. So I said, 'What criminal? What did this criminal do?' But they never gave me straight answers. Their answers kept on changing. I think they made flimsy accusations, in case I confessed to one of them. Like they were playing a game. Or fishing.

Those months are a blur in my mind. After Eastwood Prison, I was taken to Yarl's Wood Immigration Removal Centre from March 2018 to December 2018. The Home Office case worker told me there I was going to be deported back to Nigeria. I asked, 'How is this possible? I have a British passport?' They told me my British passport is fake. I said, 'Please, show me what is fake about it. Prove to me that it is fake.' But they did not produce my passport. Instead, they asked for other documents to prove my story. But because I had not been allowed to go back to my flat in Oxford, my

landlady had cleared my flat and thrown everything out, so I could not give the documents the Home Office wanted. When I said, 'This is your fault, not mine' they did not listen.

Finally, I appeared in court. The judge said there was no proof I had committed a crime. The judge said I could not be deported because I am a British citizen. I was released from Yarl's Wood, and my solicitor filed a case against the Home Office for unlawful detention.

But my life did not return to how it was in 2017, when I was waiting at the bus stop in Oxford. You see, I had lost too much. I had not been earning for two years, so I had no money. Now I was homeless. I was moved to a big hostel in Wakefield until 2019. The hostel was better than a detention centre, but it was not a good environment. After Wakefield, I was moved to Middlesbrough.

As well as my flat, I lost all my possessions. Even my good sewing machine. You do not come out of prison the same person you went in. In Eastwood and Yarl's Wood, I lost my health and my confidence. I never suffered from mental disorders in Oxford, or Norwich, or Lagos. But now I have depression, social isolation, anxiety… I cannot sleep. I lost my rights. I cannot vote. And until my legal claim is settled, I cannot work. So I am in a limbo. I have a card to buy everything I need. It is topped up by £40 every week. Everything is so expensive, it is not enough. However careful you are. I want to work. But I cannot.

My solicitor says the Home Office wants to settle my case of illegal detention out of court. But I don't know when this will happen. They say there is a big backlog in the legal system because of Covid. Maybe this is true. But it is also true that when the Home Office wants the justice system to go fast, it goes fast. When the Home Office wants the system to go slow, it goes *very* slow. Some people ask me, 'Why do you not go back to Nigeria?' Sometimes I want to say to these people, 'Why should I? *You* go back to Nigeria!' My life was in the

UK. I am a UK citizen. I have been here for 25 years now.

This is where I am now. In limbo. Waiting for justice. To keep contact with other people, to get out of my small room, I take part in church activities. I do anything organised by the local charities. I go to church. I sing in a choir. I do gardening. But it is hard to fight the despair, the isolation, the depression. So much was taken from me. Most of all, I want to work. I want to make dresses again.

When I was asked to tell my story, I thought, '*This is too painful and too private.*' I do not know if there is a happy ending. But then I thought, '*If you don't tell your story, how will people know what you are going through?*' Many people will hear my story and think, '*These things cannot happen in the UK,*' but they are wrong. This happened to me. This happens every day.

My children are grown now. I was able to sponsor my children the way that they wanted. The youngest was two years old when I left Lagos. He is 26 now. A computer engineer. For a mother to be able to raise money for three children, to be graduates, it is a big thing. So my sacrifice has not been for nothing. I thank God for that.

Yes, I have a strong faith. I thank God for my faith, also. I face a lot of tribulations in my life, but when God plants you in the midst of something, He knows how to take care of you. He knows how to rescue you from any danger. He will be there for you always. No matter what the situation is.

The Self-Advocate's Tale

as told by
Pious Keku

MANY OF YOU WILL know Ghana. I am from the northern part of Ghana where it is predominantly farming country. So I grew up on farmland. As far as I can remember, I was only about six years – five to six years old – when I started working on a farm. And then from that age to the age of about nineteen I was working on farms.

All this while, I was part of a group of children working on farmland in the presence of some adults of different ages. We didn't know it at the time, but the people looking after us were not our parents. Rather, we had been sold to them. At some point we came to know this, that the people who were looking after us had no connection to us, that they were not actually our parents.

What we had to do, basically, was to wake up very early in the morning and walk approximately three miles, four miles – depending on which farm we were going to that day – and then work on the farmland all day and then walk back again to the village where we used to live.

For the sake of time, I will not be able to go deep into the details, but will just touch on the very important things.

During the period of working on the farm, life was not easy. There were so many trials, but also there was no other option. From time to time, drivers would come to the farmland to load goods, to take to other parts of the country. We had a plantation that we would cultivate from January to December. From January to March, there was a certain type of product that needed to be grown. Then, after March, we would go to another farm. There were so many plantations that we would work throughout the year.

Life hasn't been easy. When I was about eighteen, we tried to escape, but during the escape, we were caught. When we were caught, the punishment wasn't easy in any way at all. It left scars and all sorts of things on our bodies, all a result of the punishment.

After that, there was a second attempt to escape, and the second attempt went well. We had to escape, but the escape was not easy. There were about four of us and it took us about one week, about one week and two days, before we were able to get to another town or village where we could get access to a boat to cross a river. And from there to be able to go and get a lorry to the other part of the country.

After escaping, we came across someone who was ready to provide accommodation for us. During that process, however, it became clear that the accommodation was provided not on the simple basis of kindness, but it came with conditions. Those conditions were very drastic, but we had no option but to accept them. It was like moving from one fire to another fire.

Even so, it was better than where we had been before and at the end of the day, we had managed to find a place to stay. At this time, we had a promise from somebody who was going to help take us to where the white people were living. We had no idea what this meant because we had never moved out from my country to anywhere else before.

Still, we agreed. It took four to five months before the necessary papers were prepared for our journey to the UK and

then upon arriving in the UK, that was another story altogether.

But in Ghana, it was such a very difficult upbringing I had.

★

Arriving in the UK, we were told that we had to walk very close to the gentleman who was bringing us. If we were asked how we were related to him, we should say he was our uncle, whilst in reality we never had any connection to him.

And so when we arrived, we stayed very close to him and the immigration officers — we called them police — did not even ask us any questions. The man was really looking into our face, but he just handed over our travel documents. At the end of the day, everything was okay. They just let us out.

When we got out, we followed him. The only thing I can remember was that we just followed him. Then we got into a car; the car was ready for us, with the door open ready for us to get in. We were in the car for about two or three hours until we drew up outside a house where they asked us to get out, which we did. When we entered the house, we realised that there were other people already inside. We just stood there. Later on, they asked us to go upstairs. We followed them and they showed us that this was the room we were going to sleep in that night.

There was just a mattress lying on the floor. They brought us bread and a can of Coca-Cola. That was what they gave us that night. I can remember it perfectly: the bread and the Coke they brought us that night.

We couldn't sleep, wondering what was going to happen, what was happening. I think at some point we must have had some rest, a bit of sleep, because when they came to open the door in the morning we woke up. That morning, they just gave us another Coke and a loaf of bread and told us that we would be going to work for the next few days. We wondered

where we were going to work because we didn't know, they didn't tell us anything.

The next thing we knew, they asked us to go downstairs. When we went down, there were a lot of people in the lounge. There were probably about ten or eleven of us, all living in the same house.

We got into a van. The back of the van was parked very close to the house's front door and its back doors were wide open. We were told to simply get in and sit down. They closed the doors and off we went. We didn't know which route we were taking or where we were going. The next thing that would happen is that the van would be opened again. When the van door next opened, we'd find ourselves in a very big building, they would just ask us to come out.

Then when we came out, what we had to do was clean electrical gadgets. We'd sort out shoes and clothes as well. They'd show you what they wanted you to do. With electrical gadgets, you had to clean them very nicely and put them aside. With the shoes, you looked at the ones that were good. You'd pack them somewhere else, the same with clothes.

We'd bag them up. Later in the day, towards evening, a truck would come. We'd have to put all those bags of items into the truck before it left the warehouse.

Before this, I'd never travelled anywhere, I never even knew there was such a place as a warehouse. It was actually a big room. Until we escaped, I never knew that such a place was called a warehouse.

This is what my first few months in the UK were like.

★

Staying with these traffickers in the UK was not just for a month or two. We're talking about more than a two-year period that we were under these traffickers. Nor were we just working in one warehouse. We were moved to different places

around the UK.

When the issue was reported to the authorities, later on, they did investigate it. When they went to the various places we showed them, they discovered that the people were moving warehouses. They were moving from one place to another. That's what they do. They are masters of trafficking. They don't stay in one place for a long period.

At the time of our escape, I tried to report them to the authorities. I went to the police station and I reported the case. I said, 'Look, this is the situation and I need help.'

But when I reported it, I was arrested and put in a cell. They said Immigration was coming. Even at that time, I didn't have any knowledge about immigration or anything. They just said, 'Somebody is going to come to see you and they will help you.'

They came later in the evening, it might have been dawn. I was locked up for almost twelve hours before somebody came and asked who I was, what my name was. I gave all the information. They said they had no record of me, that they had to take me to the immigration centre. At that time, I didn't even have any knowledge about the immigration centre or anything. It was only later that I realised I had been taken to a detention centre.

During that period, it was a very difficult time for me. All in all, I was locked up in detention for over three years. During this three-year period, two and a half years were continuous. In between, I was temporarily released.

During my release, the condition was that I needed to sign every week. Not even every two weeks, or once every month, but every week. They were not supporting me. They were not providing anything for me. I reported each week and then, one day, again, I was re-arrested and taken back to detention.

When I asked them, 'Why am I being re-arrested?' the only thing I was told was that: 'Your caseworker has authorised your re-arrest.'

I said, 'For what reason?'

They said, 'When you get to detention, you'll be told the reason.'

Until today, up until the very moment I'm writing this, I've never been given any reason why I was re-detained twice after release.

All in all, to repeat, my detention was over three years.

★

I continue to call for an end to detention because detention really has a very negative impact on humanity. I am here sharing my story with you today, but I could not do it without the help of Gatwick Detainees Welfare Group and without the help of most of you sitting here today.

In particular, I want to pay tribute to my visitor, Mary Barrett. She has been an inspiration to me, and she has been the main reason I am able to stand here today speaking to you. Week in, week out, she came to spend time with me, to talk to me, to encourage me, to empower me, to voice the conviction that we will continue to fight.

This is what they do. All the visitors that come to detention centres to visit people, they try to empower us to use our voice. And I'm calling for an end to detention because it's having an adverse effect on humanity. We are all human. We breathe the same air that God has created. We are not different in any way.

Detention is so damaging. It causes mental health problems for so many people. After detention, they have to seek counselling each and every day, each and every week, each and every month, because they just cannot cope with what they have gone through, what they went through.

That is the main reason I continue to call for an end to detention.

★

As for my own personal experience, I waited for eleven years to be granted leave to remain. During these eleven years, I tried everything possible to get something done, but the authorities would not allow me to do anything.

Anywhere you go, you ask, 'Oh, is it possible for me to come to volunteer?' Not to work for pay, but just to volunteer. I was asking for this because I just wanted to get out of the house. I just want to get out and go and do something. But the only answer I got was, 'We are sorry, we can't give you anything to do. You can't even volunteer.'

And if I ask why, they said, 'Well, the government policy does not allow them to employ or give work to anybody as a refugee who has not got leave to remain in the country.'

And I would say, 'I'm just trying to volunteer.'

And they would say, 'Well, we are sorry, we can't, because government policy does not allow that.'

And I would keep asking, 'What sort of policy is this?'

But they would say, 'Well, that's it. We can't.'

I even tried to go to college, tried to do something for myself, but I was not allowed to.

Anywhere you go, they will say, 'Oh, we need your ID. We need your this. We need your that.' And you don't have it. The only thing that you have as an asylum seeker is just maybe a sheet of paper, an A4 sheet of paper, or sometimes you have an Azure Card in your hand, and they will tell you that is not enough, we can't accept that.

It's very difficult. You can just imagine for these eleven years, if I had been working, I would have done something meaningful for myself, but I was not allowed. So eleven years of my life has been wasted. I'm not getting younger and eleven years of my life have just gone down the drain.

In this country it's so difficult, When you seek asylum the government will not even allow you to do anything, not even voluntarily. They will not allow you to do anything. That is how difficult it is.

★

I continue to call for an end to detention, and I continue to challenge MPs and people of influence that if they want to know the reality before they sit down to pass any legislation, or make any regulation, or any policy as far as immigration is concerned, they need to feel and test how it is.

So, if any politician is reading this, I want to challenge you to come with me so we can go to a detention centre to spend a week there, no, more than a week. So that you can experience detention, so that you can go in as we go in, as if we are illegal, go through the whole process, be searched, have your life taken away from you totally, I mean have access to nothing outside.

Just one week in detention, so you go through the same process as any detained person. So that after one week, when you come back, you'll be able to advise other politicians how it feels to be locked up, what it means to be in a detention centre. You wake up and the officers will come and then bang the door, not because they want to open the door, but just because they're just passing by, and then they'll just bang the door because they are in control. They do whatever they want to do.

If you want to go to the hospital, they put you in chains. You are not a criminal, you have not committed any crime, but they will put chains on you before they take you to the hospital to be attended to. I remember whilst in detention, when I wasn't feeling well, I was meant to go for a hospital appointment. They took me to the hospital and brought me back without being attended to, simply because they took me there, handcuffed me, put chains on my legs.

I'm not a violent person. I've never been involved in anything violent.

When we got to the hospital, the doctor said, 'Can you

take the handcuffs off and take the chain off this gentleman so I can attend to him? He's my patient.'

They said, 'Okay, we're going to be outside, but the chains are still going to be on him.'

The doctor said, 'I'm sorry, I can't see to my patient whilst he's in that condition, in chains. If you don't take them off, you'll have to take him back.'

Truly, they brought me back to the detention centre. And when we got back, they said that I had refused to allow the doctor to attend to me. They believed them. This was G4S that was in charge then.

I have been detained in detention centres all over the UK. I have been to every single detention centre throughout my period in detention. I know what I'm talking about when it comes to detention.

As for policy makers, I would ask for volunteers to go with me to spend one week in detention. Probably when they come back, they will have a change of policy.

There's the challenge.

★

It's a relief to be able to say that I've finally been granted leave to remain. But there's still this trauma that others have to go through on a daily basis. I thank everyone who has helped me, listened to my story and contributed to where I am today. It has not been easy. It's been a very difficult journey. But it's wonderful to now be at university, which has been my dream. What I most enjoy is assisting members of marginalised communities and giving them the tools they need to better their own circumstances and take care of themselves. Creating resilient communities makes it possible for us to help one another, coming together during trying times, and to advance as a society.

On the other hand, what I have learned on the course is

empowerment; this course has empowered me to be able to speak out now, to express myself and work together in a community. Today I can work with others to improve the society we live in and feel proud of our community. Also, I have learned the value of collaboration amongst stakeholders who are committed to defining and resolving issues within the community and pursuing possibilities necessary for successful community development.

What I hope to do, once I have graduated, is find a position in project-based community work that addresses particular issues like homelessness, poverty, education, drugs, sexual health, advisory work, community arts, or regeneration. Social work would be my dream job. I would love to increase my self-esteem and confidence, and with that my participation in political and citizenship activities.

The Thirteen Year Tale

as told to
Hannah Lowe

1

THAT PHOTO OLIVER TOOK on the library stairs –
I'm tall – too tall, I said and stood two steps
below you, and brushed my coat down, patted my hair.
Smile! Oliver said, instructing our lips
and smile I did, but when he sent the picture
your face is flat, unsmiling, although your eyes
are wide and open – a frank unwavering stare –
but what is there to smile about, it says.

I look so small beside you, and you a giant –
having told me over lunch a story
so large and full of sorrow, misdeed and drama.
I wonder how to write what you have spoken?
A tale in which, at best, you are the broken
hero, and this country, where we live, an ogre –

2

In your country – nameless now for safety –
twice you were tortured. *Torture* – the word floats away
on the pristine air of the British Library café
but later, I listen back: *torture*, you say
and nothing more, which leaves me wondering
what horrors that word stands in for. One night,
they came for you again, three men forcing
the compound gate, boot-steps, a sweep of lights.

Your wife and daughters hid below the bed
while from the balcony you hopped a wall
and ran, and left your laptop on the table –
all the names and addresses it held and shielded.
You wore a T-shirt, shorts, no socks or shoes –
only the clothes on his back, the old phrase goes.

3

Now *home is the mouth of a shark,* what else to do
but run or hide, as you did, in the boot
of someone's car, weaving the avenues
and turning corners, out towards the airport.
In the hot dark air, you heard the plea
of your wife (one last time, you saw her,
and your daughters): *je veux venir aussi.*
Ne pleure pas, pas de larmes, you answered.

They gave you sunglasses and a baseball cap
to move through departures, like a movie scene
except the bullets here are real, the kidnaps,
the murders. In the pocket of your jeans,
the only fake thing: a passport, your face in frame
below the plastic, and a stranger's name.

THE THIRTEEN YEAR TALE

4

You can claim asylum Monday to Friday.
You go alone. They find you a translator.
The interviewer says *you arrived on Friday,*
but whereabouts in England did you live before?
Je ne vivais pas ici, you state,
Je ne comprend pas. He reverses the question,
but his questions look like fishing bait

and you the fish, a hook flung close to your mouth.
Je ne comprend pas you tell the translator.
Why didn't you go to France? asks the interviewer.
Or Belgium? You'd wanted either. His question
hangs in the air. *You must tell the truth,*
the interviewer says. *Or else, detention.*

5

You're *dispersed* to Cardiff by a taxi driver.
Deep winter. Two pairs of trousers in your holdall;
two shirts; a jacket – blue – a pair of trainers.
Grey sky above the hostel. Inside grey walls,
and chains of ants across the windowsills.
You walk the streets. The docks are a reminder –
ships sailing in and out, departures, arrivals.
At Mermaid Quay, two bodies cast in sculpture -

a woman reaching out to Africa?
They send you off to Plymouth. I ask how long
Two years. Two years? Two years. Still no reply.
You phone your wife, her voice is like a song.
More interviews, more questions And then the letter:
your asylum application is denied.

6

The appeal solicitor is called Eleanor.
Oh no, the men from Guinea say, the men
from Mali. She's the wrong solicitor –
she deals with family – she's never won
an asylum case. You meet for half an hour
before your trial begins. She asks half-questions
like unopened flowers, half-hears your answers,
In court, she wilts and flounders. Your application

is denied. They give you weeks to leave.
You stay and claim the sofa. All day long,
the men from Eritrea, Sudan, Bhutan
watch the telly. You only sleep when someone
finally turns it off, a sweet reprieve.
You wake the moment someone turns it on.

7

but new evidence has since come to light and is pertinent to the case…

Fresh claim. I search the term for anagrams –
small words it holds inside, say *smear* or *file*
or *fish* (like a minnow swimming hard upstream)
or *clam* (you hanging to a rockface while
the huge waves try to wash you off, away).
This kind of searching is a thing I do
with language, making lists and dossier,
interrogating, poking it for clues.

More years have passed. You know the lingo
of migration and asylum – *points-based system,
dispersal, port of entry, leave to remain,
PTSD*. You're back where you began

residing on the sofa with a biro,
another form. *Fresh cream. Flames rich. Fresh claim.*

8

Always
the plan
was for your wife
and daughters
to join you
when you
had settled
when your status
was settled
but your wife
died
and her sister took
your daughters across
the border, away

9

You want to go home. What does it matter
now she has gone? Who were you staying alive
for? Who are you a husband to, a father?
Now, why are you saving yourself? Why try to live?
Why try to live? How many wasted years
wandering the streets of English cities
you never knew existed, always the fear
of detention, deportation, counting pennies

for bread, and staring at the TV screen
with the men from Eritrea, Sudan, Bhutan,
watching cities explode then crumble, the troops
parading in, and madmen stood in jeeps

with rifles, bombs in the mosques and churches –
the light of war playing across your faces.

★

You can't go back, your friend from back home says.
You'll be arrested, he says, *on the plane, at the airport.*

You are a traitor. That's what they will say.
Ils vont t'assassiner. Tu seras mort.

He is so certain, while the Home Office delay
then deny your claim again. You take the train

to London, where the bird of grief most days
appears to tap-tap-tap your windowpane.

You only leave home when home won't let you stay,
he sings. *You never should have gone away.*

10

But slowly love arrives, step by step,
pulling a suitcase, holding the hand of a child.
You knew her once at home, over the mountaintop
of time and space and loss, in that other world –
remembered, misremembered, illusory.
Georgette. Some afternoons you babysit,
some nights you curl to sleep on her settee,
the night-time sky outside is hopeful, starlit –

Should we get married? one of you asks the question.
Georgette has EU citizenship. You can gather
your daughters, all of you can live together
and have another child perhaps, and make

a family from the ash and sparks of heartache.
This idea hangs in the room, a spinning moon.

*

Where and when did you meet your partner?
What does your partner do for a job?
How much time have you spent with your partner?
What language do you speak together?
How do you keep in contact with your partner?
What does your partner do in their spare time?
Have you met your partner's friends and family?
What are your partner's family like?

What are the names of your partner's family members?
What religion are you and your partner?
What do you like about your partner?
What do you have in common with your partner?
What was the proposal like, and when did it happen?
Have you ever been refused a visa in the UK or another country?

11

The interview goes on
from ten am until three

at which point
they arrest you

place you in a van
and drive you to detention

They tell Georgette
she is in trouble

she'll be sent
back home

the pair of you are lying
is what they say

but it is them
who are the liars -

(*you never see Georgette again*)

12

A month goes by before they try to fly you
but Zaccariah tells you what to do –

Say no. Before they get you on the plane.
Say no? you ask. *Say no, again, again.*

Then hide or else they'll beat you. And so you do –
say no, then hide for hours in the loo –

it would be funny if it wasn't funny,
this kind of life-or-death tomfoolery.

This happens twice, but Zaccariah's wisdom
outwits them. He is Sudanese – a pundit
of the detainees, though most of them
are experts in the system and have survived
the immigration high-rope, acrobats
performing somersaults to save their lives.

★

THE THIRTEEN YEAR TALE

Your
thirteenth
year
in Britain,
you gain
asylum.
Detained,
you find
at last
a good solicitor,
who helps you
walks you
through
the door

13

Dear Monsieur, here is what I wish for you:
No more of sofas, but an enormous bed
where the jumping-horse of dreams will take you
where you need to go in sleep. That bed
to fit a room you call your own, in a home
that's yours, with Bete music on the radio,
where a bell ring brings a friend from home,
and over coffee, a song you used to know

starts playing, and you almost sing along.
To see again your daughters, to hold them close
and find your wife's face in their faces, to find
your country in their faces, the way you often
see it in your own, turning from the mirror,
a glimpse of who you were, before the war.

Notes

The lines *home is the mouth of a shark* in Section 3 and *You only leave home when home won't let you stay* in Section 9 are taken from Warsan Shire's poem 'Home' in *Teaching My Mother How To Give Birth* (2011).

The sculpture referred to in Section 5 is the 'People Like Us' bronze on Mermaid Quay, in Cardiff, which represents the historic diversity of Cardiff, as a port town, and in particular the multi-ethnic area of Tiger Bay.

The questions from Section 12 are borrowed and adapted from an online list entitled 'UK Spouse Visa Interview in 2024' by Amar Ali.

The Patient's Tale

as told to

Natasha Brown

'Your life is going to change,' the ophthalmologist told me.

I was at John Radcliffe Hospital in Oxford, the eye casualty clinic. An urgent appointment.

'You are not going to be able to live a normal life,' she explained. 'You've lost 65 percent of your vision, and that's likely to worsen in the next few years.'

'There's nothing I can do,' she said. 'If I had seen you earlier…'

*

I was arrested in 2016 and taken to a detention centre. I'd never been arrested before. Never been involved with the police in my life. When I arrived at the detention centre, I was still in handcuffs. They 'processed' me and took my fingerprints. When I was let into the courtyard of the detention centre, I looked up at the fence. It was so high. It stretched all around. My heart jumped into my stomach. I realised then that this was a prison, it was really a prison. Would I ever leave this place?

While I was there, my vision began to deteriorate. There's what they call your 'monthly progress reports'. I couldn't read those, the text was too small. I started bumping into things because I couldn't see properly. Even the immigration detention centre officers noticed it. I was booked in to see a doctor at the detention centre. I waited weeks, months, to see a doctor. But when it was time for me to see the doctor, I was moved to a new detention centre. And at the new centre, I was at the back of the appointments queue again.

All the time, they told me, 'You are on the list to see a doctor.'

Months passed. It was getting worse. I started having blurry visions, flashing lights. One morning, at about eight or nine o'clock, they finally told me they'd called an ambulance. The ambulance didn't arrive until that night. I was put into handcuffs and taken to the hospital. In the ambulance, I sat between three detention officers. They were talking among themselves. Probably to scare me.

They began to talk about what they've done to other detainees, how they beat up a Turkish boy who was about to be deported. They boasted of how they had dislocated his shoulders, saying that he must be deformed in Turkey now.

They said a lot of horrific things.

I have to hope that they just said it to scare me, because I can never imagine human beings being so – so monstrous. I can't describe the words they used to glorify it. Those were words of hatred.

At the hospital, the doctor said that she was a general practitioner, not an *optician*. She recommended that I should be taken back to the detention centre. And so they took me back.

★

You are in fear. You are in constant fear. You're in your room, next thing, there's shouting: Bang up! Bang up! Bang up! The

officers start to lock everybody up. You hear screaming. They're dragging someone off to the plane. You don't know when it's going to be your turn, when they are going to come for you and drag you to the plane. You're in a constant hypertensive state.

★

I was taken to a detention centre in another part of the country. They had a library there! When you're in detention, you're looking for distractions. You have nothing, there's nothing to do there. But I couldn't borrow books because I couldn't see properly. That's where I met Anna. Anna found out that I had a vision problem, and she provided me with a magnifying glass. She enabled me to read, to take my mind away.

I was moved again. This time to a centre near Gatwick Airport. There, I met some wonderful immigration detention officers. They recognised that I had a problem. There's one I'll never forget. She came to see me. She sat down with me in my room to talk about how she could help me. She arranged for the welfare team to speak with me about what they can do. They put me in a room on the ground floor and gave me equipment to shower in my room, so I wouldn't have to go upstairs to the general shower.

I was going to be moved again, to another detention centre. The move would be difficult for me, because of my vision loss: when I'm not familiar with the environment, I find it very difficult to navigate. I didn't have a mobility cane then. The officer supporting me opposed the move, and I was able to remain in the same detention centre until my bail hearing. The Home Office argued against my bail. But at the hearing, after the judge reviewed my condition and my medical records, I was released on compassionate grounds.

Once I was released, the family I was staying with arranged

a GP appointment for me. The doctor performed some tests, then he immediately called an ambulance to take me to the hospital. I spent two or three nights at the John Radcliffe Hospital, and they arranged an urgent appointment with an ophthalmologist. I was told how my life would change.

★

Today, I have my resident permit card. It seems over.

But there's a fear of the system inside of me now. That kind of fear remains within you. If you get a tattoo on your skin, it's there for life. That's what my experience of detention is. It's like a tattoo on my heart. It can't be erased. You'd have to tear me up, dissect my skin, before you could erase it. That's the way it is in my heart. It's lost.

It's lost.

But what can I do?

The Leader's Tale

as told by
Osman Salih

I AM OSMAN. I am from Eritrea originally. I was born in Keren and I began my life on a small farm.

I studied in a normal government school, until grade seven. Then one time, my mother gave me some money to go shopping, and the military police caught me without my student ID, which I had forgotten, and took me directly to the military camp to join the army. I was seventeen years old at that time. I was taken to the military camp and for six months we had training. There were over 65,000 soldiers at the camp. People from all over the country were brought there for training. This was in 1997. My mother was told that I had been taken.

After the training we went to the front line to defend our country. The government brainwashed us, saying that Ethiopia wanted to take our land, our border. We trusted them. We went to the front line to give our life up at that time.

After two years the war stopped; the United Nations soldiers came and we withdrew from the front line. At that time the government started dividing the soldiers between building, farming, machinery and other departments, while

some continued with military work. There was great corruption and so many of us soldiers refused to take orders from the leaders. After eight years in the army, I was one of them. I did not want to stay all of my life in the army – I needed to go back home. Many of us could not see a reason to be in the army now that the war was over, and we could see that we were working to fill the pockets of the leaders, while our stomachs were empty.

When we refused to follow, they took us to prison, me and many people like me. This is the country to which I gave my age, my blood, my time to defend its border. They took me to prison. That's my first point.

★

I decided I had to escape from that prison, had to leave the country. I wanted to live as a free person, I wanted to live like a human being.

The chance finally came. A group of us, maybe twenty of us, we escaped from that prison. A fire started and me and my friend Mikaeli, we ran together. We hid ourselves all day in the height of the mountains and then at night we started walking.

We were soldiers. I had lived in that military camp, so I knew the soldiers' habits, what time they moved, what time they got dressed. When we had to, we hid to save ourselves. And then after one month, we got to Sudan, to the border. When we crossed the border, I felt very bad. I had given my golden years, and lost so many friends, defending that land, and finally I had to leave. It was like I had buried my dream. I did not know when I would come back.

Then we started life in Sudan, the same as many Eritrean people.

At that time, because we lived illegally, the Sudanese government would take Eritrean people to prison. Once in prison, you had to pay them money. If you paid, they would

release you, so this was not a change of life. We struggled to live there.

At first, I lived together with Mikaeli. I built up my life, working as I could in Sudan, and I learnt to speak Arabic from the street. I met an Ethiopian lady, and we got together, and she came to live together with me and Mikaeli. We had a son together, Hamudi.

Mikaeli decided to leave in 2009, to go to Libya, but by this time I had my partner and we had our one-year-old son. It was then that I stopped journeying with Mikaeli. I had my son to look after and so when Mikaeli decided to go to Libya, me and Miki we were divided into two. Then in Libya the war started following the overthrow of Gaddafi. Mikaeli left. He died trying to cross the Mediterranean when Libyan soldiers shot at his ship. So I lost Miki in the Mediterranean.

*

For some reason, my son's mother had to go back to Ethiopia. I came back home from work to find my son with the neighbour. Because we were not married, and we were of different religions, she had no paperwork to show that he was her son, and so she would not have been able to cross the border with him. So she left the boy with the neighbour, and she left. After this, my mother had heard that I was in Sudan, and so she left Eritrea to come to Sudan.

In 2012, I decided to leave my son with my mum. There was no choice, I had to cross the desert and go to the Mediterranean. There was no change of life in Sudan and the human traffickers they told us, if you go to Libya you will have a better life than in Sudan. We trusted them. We collected 1,500 dollars and we paid them. And then we started the journey, 30 people in total – the long journey across the desert to Libya.

The Sudanese traffickers said they would continue the journey until Libya, but in the middle of the desert the

situation changed. They had new business with Libyan traffickers. They took us to the place of exchange, the border of Libya, West Egypt and Sudan, at which point Libyan traffickers replaced the Sudanese at the head. I asked myself at the time, how can I finish my journey with these people. I thought they would leave us in the desert. But we had no choice and so we all jumped into the Libyan car.

And then we started and they told us we had to pay extra money. The people who had money, they paid. But for people like me that don't have money, what do you do? They said you have to send it from your family, but if you cast your mind back you will remember that I left my mum with a three-year-old son. I knew my mum's situation. I knew she could not pay the extra money. I said to them, I don't have money. And so they said to me that they would sell me to people, people I would have to work for, for free.

And so some people came, rich Libyans. They paid money to the traffickers and they took people for work. One person, whose name was Jaffer, wanted two or three people, including me. In the middle of the desert I had to do shifts for six months. When they took me to the desert, he talked to me about my job, and what I would do in the desert for him. He had two hundred sheep, and I had to watch them. He says if any of those sheep died, he would kill me. Every three days he would come with a big tanker of water, food, and then he would go back to his place. Around the area were also his family, who would watch me. And finally, if I had wanted to escape, where would I go? It was the middle of the desert. So finally I told myself, I had to be nice to the guy, so he would release me. So I worked hard for him for my freedom. Then after the six months finished they took me back me to the trafficker in the city and I was released. When I asked for some money for my six months work, he showed me his gun. He asked if I needed money or if I needed life. I said thank you and left.

★

I found some Sudanese people. They shared money with me. With that money, I went to Benghazi and from Benghazi to Tripoli. I started life in Tripoli, doing daily work with Sudanese and Eritrean people. I saved money, maybe for one year. And then I decided to cross the Mediterranean, to go to Europe to save my life and then, afterwards, to save my son's future. That was in 2013.

When we started the journey, there were 85 people in one eleven-metre boat. You either live or you die. I know the sea, I know that it eats us. I knew I would not be the first Eritrean person to die in the sea, just as I would not have been the first Eritrean person to die in the war. If my days were finished, I would live in the sea. If I was still alive, I would win. I would be a free person.

We crossed the Mediterranean but after travelling for 24 hours without pause, in heavy waves, the engine stopped. The driver also was one of us, a passenger, so he did not know how to fix it. We stayed three days and nights on the sea, not knowing what would happen. Every hour we would find ourselves still alive, and say yes, we are still here, we haven't died. Every single minute we counted, we might die or be saved. Anything could change in a second. Finally, some Tunisian fishermen saw us from their ship. These people called Italy and the Italians, they came, they rescued us. They took us to Lampedusa.

When I say Lampedusa, I have many memories. From the time we had been surviving, counting minute to minute, that was the first time we came back on land, from the sea. Also, the memory of the Tunisian people who had rescued us and called Italy, and the Italian rescue team who has rescued us, for no payment. This is also included in the memory. So we saw in their faces they had returned something to us, returned our lives to us. I don't want to pass without saying thank you to

them, for rescuing us all.

In Lampedusa we found people like us. Then we came to an office, they took fingerprints and pictures, we did not know what was happening, or know the language.

And then the next day they took us to Sicily, to a huge camp close to Catania, called Cara di Mineo. When we reached the camp, we saw a lot of people there. They offer accommodation in that camp. We shared with everyone – the old people, the new people, they were all mixed together. In that camp you have to wait for an interview. They take ages, up to two years. In that camp, the service is not good. They told us you have 2.50 Euros each day at the camp, but all they gave us was one Marlboro cigarette packet every two days. If you smoke, or if you don't smoke, doesn't matter. They don't give cash. I stayed in that life for nearly two years. Finally I had my interview, and they gave me the right to remain in Italy.

★

In Italy, after they give you papers, they just kick you out from the camp. You have no language, no means of communication, no house, no support, no job. How can I survive? Every single day I struggled to buy food. Finally I decided to go to the bin. I jumped into the food bin skip, I collected some food, I ate, because there was no other way; the weather was cold, I felt hungry. I started to eat, I looked for clothes. I slept under the fronts of shops in Catania. That is my second point. I arrived in Europe, I went to the garbage to find food.

After a couple of months, I said to myself, okay, let's go somewhere. Don't worry, you will get past this. So I started looking for a job. No jobs. We went to traffic lights and asked people for money. Sometimes, if you collect people's trolleys at supermarkets, people might tip you with money, or give you food. On some days we had it like this, we managed; on others, we went to the bins. So I went to Messina, to look for

work, but the problems were too great. Palermo. Roma. The same. Finally, I decided to leave Italy.

I saved my money, got a ticket, and went from Roma to Milano. From Milano to France. Paris! I paid 60 euros, I think. I didn't know when I crossed the border. I remember, I was sleeping on the bus, and a policeman came and asked me for documents, I showed him, and I went back to sleep. I think maybe that was the border. Morning, in Paris, I thought maybe I was still in Italy.

I had heard that from Calais you could go somewhere, to the UK or everywhere, and so I thought that was the border. France, Italy, I did not see any difference. So I followed others to Calais. I met a lot of people in Calais. People lived in tents, and then every day they tried to jump into the train, and then I followed them. After two weeks, I got a chance to jump on a train, and I reached the UK.

★

When the train stopped, the security saw me. They called the police. The police, they came to me, they asked: do you have a knife? They made a check, they took me with them – to the police station, immigration, I don't remember now. In that place, they told me with an interpreter, you are in the UK. Then I told them who I was, and why I had come to the UK. I explained to them what happened in Italy, what documents I had. I had lost my documents, my wallet, in Calais. I told them the whole truth.

I spent 12 hours there. And then the Home Office, they told me they were sending me into detention. One of them said to me, you have to use the toilet, you are going on a long journey. I said, okay, where to? I don't know, he said.

★

When I saw the car, the prison car, my heart started to beat. I felt something going from my body. And then, when I saw the immigration centre, the checkpoint, the gate, I saw that detention was a prison. I started asking myself, where are you going, Osman? What are you doing, you have made a mistake. How long will it be like this?

What I saw was a prison. I had escaped from prison and I came to Europe, to England. I had been in prison already. Was this the goal? Was this the dream? No. Was this right? No. If I needed prison, we had more than 350 underground prisons in my country. I didn't come to the UK to be in detention without any crime.

I had asked for help. I needed help. That's why I held out my hand to immigration. If someone gives you their hand, they need your hand in return, they need your support. But the Home Office, they put us in detention, so I shut down my hope. I saw all my dreams disappearing.

When I was in the camp, in the military, when I was doing the training, they had a policy of brainwashing. One of the things they said was that Europe, the West, is no good. I trusted them at that time. And then, when I came to the UK and was sent to detention, I said to myself, actually my government was right.

That was the thought that came into my head, that I made a mistake when I left my country. This is my third point. I had come to Europe and lived on the streets. Now, in the UK, I was sent to detention. I didn't know how I could leave. So where are human rights?

★

Finally, they gave me a ticket to deport me back to Italy. I was taken to Gatwick Airport. I refused to get on the plane. The pilot, he refused to take me and so I was sent back to Tinsley House detention centre.

THE LEADER'S TALE

At that time, before I got the ticket, I asked one of my friends in the Dover detention centre what to do. He said to me, Osman, show the ticket to Rosa, from the visitor group in Dover, maybe she will help you to cancel your ticket.

I said, 'Okay, I will show her.' She said to me, 'Osman, you don't have time. The flight is Friday and you only have one day. If I can find a solicitor to help me, I will try to cancel the ticket, but if I can't, I will let you know.'

I thanked her and on the Friday morning she phoned me to wish me luck, but she also said, 'If you don't go on the flight, call me.' So when I was sent back to Tinsley House, I called Rosa to tell her. She said, 'Where are you, Osman?' I said, 'At an airport in the UK.' 'Which airport?' she asked. I said, 'I don't know.' I didn't know because I had never stepped out into the UK. I had moved from the train to detention, and from detention to the airport for deportation. She told me to pass the phone to any detention centre officer nearby. I passed her onto an officer and they told her I was in the Tinsley House detention centre at Gatwick Airport. She said, 'Okay, I have to check the website,' and then she told me she could arrange for someone to come and visit me. 'I will make the arrangements,' she said, 'somebody will visit.'

*

Visit. The meaning of that word is so important. It means that somebody comes to see you. It means you feel like you are a human being on this planet. You feel like you live the same as other people, like you have rights. After so much difficulty you need someone to look after you. You need to think that someone cares about you.

I had lost hope. I needed someone to say to me, Osman, I am with you. Osman, I am on your side. I needed to feel the power of that person. I needed that one.

And then, Rosa, she phoned Anna. And then Anna

phoned me. She said to me, 'Are you Osman?' I said to her, 'Yes, I'm Osman.' And then she said, 'Are you happy for us to come visit you?' I said to her, 'Yes.' She said, 'I will send Celia.' In all my time on this planet, I never saw a person like this woman. Celia is the light of my life.

I learned from her. She gave me her time. She gave me power. She gave me light in the dark time. Until I die, I will tell every person I meet about her. We need people like Celia on this planet to live in freedom. Trust me. You don't know her but I know the feeling she gave me, how she rescued me.

When she arrived, I didn't know how to communicate with her in English. But she understood how to talk to me. I spoke to her in my language, in Tigrinya. She understood my message. I spoke to her in Arabic. She understood and I understood what she meant when she talked to me. She said to me, 'Osman, I can't take you out from this detention, but if you feel alone, please see me as part of your family.' I said, 'OK.'

She came every Wednesday. She visited me in the detention centre, in Room 2. Always I was excited to go to that room. It was the same building but that room was different. If you needed to go to that room, it meant that somebody had come to look after you. So the feeling in that room was different. When it was Wednesday, I knew that Celia would come and I would be very excited. She would come and I would chat with her and afterwards, when I went back to my cell, I slept well.

In the end, Celia told me about Section Four accommodation and about bail that would have to be granted by a court. I applied and then I got a letter. On 28 October, 2015, the letter said, at 6 o'clock in the evening, I would be released from detention, from Tinsley House. They gave me an address in Cardiff. They opened the door and said to me, go.

★

I didn't know where I was going. Celia put ten pounds on my phone card. The detention centre staff gave me five pounds, one pound coin and two two-pound coins. I didn't know which coin was which, I just put them in my pocket.

I took my bag. I had to ask someone to show me where to go. I went to a train station and at the train station they changed my letter for a ticket. They said I had to change trains at Reading. I asked some passengers to help me, and then finally I reached Cardiff Central Station.

From there, I had to get to the Link's Hostel. Again I asked a passenger to help me. He said you need bus number 45, follow me. And when he saw the bus he took me to the driver. The driver said, 'Do you have money?' I said, 'Yes, I have.' I showed him the address. He said, 'Okay, put in the money. I took two pounds and put it into the machine and I took my ticket. I stood close to him all the way. Every single stop, when he stopped, I asked him and he said, 'No, no.' I didn't want to sit, because maybe he would forget. Finally, he said to me, 'This is you,' and I said, 'Okay, thank you.' I went to my hostel. I had been released at 6 o'clock and at 10 o'clock I was at my new address.

The next day, Migrant Help contacted me and I went to the Oasis Drop-In Centre for Refugees and Asylum Seekers. They had computers there for people to use for free. I made contact with my friends on Facebook and I sent my family's contact number. I told my friends and I told Migrant Help that I needed to contact my son, because for almost a year my son hadn't heard my voice. And then suddenly, one morning, I opened my Facebook and everyone was saying, 'Welcome, Osman, welcome!' Then Migrant Help gave me a landline and I made a call to my son. I heard my mum and my son for the first time in a year.

★

After that, I started my new life, signing at the Home Office reporting centre every two weeks. Take your belt off, switch your phone off, and so on, and so on. They make stress for you. Every other Wednesday, I had to sign. Then, after seven months, when I went to sign, they detained me, again.

They took me to Cardiff Bay police station and then the next day they took me to the van. They didn't have any reason to detain me because I hadn't missed any signings. I told them about my bail but they didn't answer. Why they had detained me, I didn't know, but still they detained me.

And then I called Celia. And Celia, she came to visit me again. Look at this lady. She would not give up. She would not tire. She climbed the mountain of detention. I didn't pay her one penny. She gave me everything – money, time, power, everything.

She emailed my solicitor and my solicitor emailed the Home Office. And after two weeks the Home Office sent a Dragon Taxi from Cardiff to pick me up. The taxi took five hours. The driver arrived at one o'clock. They released me at five o'clock. He drove five hours back. Fourteen hours they pay them, the Home Office. And that money comes from where? From your tax, guys. They pay to make stress for me, the same as with other detainees. I need freedom. I need to be a free person. The same as you, the same as any person living on this planet. I didn't come here to be in detention, to sign.

★

After four years of waiting, I had heard nothing from the home office. Eleven solicitors had worked on my case. The solicitors, they would come and they would say sign here, sign here, and then they would leave. After six months, they would say to you, I left your case.

'Let's try another,' Celia said to me, so we tried Duncan Lewis and the solicitor at Duncan Lewis made a fresh claim.

The home office sent a letter asking me to go to an interview. When I saw the letter, I was happy but also confused. I'd waited five years for this day.

I did the interview. I told them everything. They said they would give me a decision in 20 days. They sent a letter to my solicitor. It said I was granted five years leave to remain in the UK. I said, 'Thank God.'

And then, Celia, she helped me to complete the family reunion process. The son I had left at three years old, I met him again at 12. I had given my mum such a big responsibility. She was 75 years old; she has high blood pressure, diabetes. She could not work but she had a big responsibility. I couldn't work to help her. The home office, they gave me £35 per week, of which I saved £20 so that I could send her £80 each month. Each week, I used only £15 pound for me.

The Home Office, they affected my mental health. They affected my son. At the age of twelve he had hardly been in school, he had never played like other twelve-year-old kids. He blamed me, but the fault wasn't mine. For the fault we have to go back to the Home Office. They caused me great stress by detaining me, with all the signing and all the waiting. And my son, it affected him because he was not able to go to school. He missed his mum, he missed his dad. He lived with his granny, a 75 year-old woman. For all of us, they damaged our life.

*

So finally, I had been granted leave to remain in the UK. But this is my last point. If they could grant me the right to live in the UK, why did they waste my life? That is the question.

Why did I leave my country? For all these reasons I tell you. Also, the government takes people to the army without choice, without finishing their education. They destroy their dreams, their future. Because if people have not educated

themselves, they cannot realise their dreams. That is why we left the country. Many Eritrean people, they only think of how to escape. That is what many Eritrean people think. They know if they stay they will have to go to the army. So young people do not think of school, they think of how to escape. So there are no educated young people.

When you come to Europe, the journey is very difficult. The desert, the Mediterranean, and then finally you come to your destination, and still you have problems, and so all of this trauma it comes to your mind. All the war, it came to me. I struggled to sleep. I spoke to my doctor, I took sleeping tablets, even with the tablets I had side effects, my body became addicted to them. Your body is tired in the morning.

So why am I doing this? Why am I sharing my tale? I take you back to my claim. You need rights. Even here, you are in detention without any crime, you lose your time. So we need to fight to get to a solution. We will fight to get our rights.

The Dissenter's Tale

as told to
Daljit Nagra

I THOUGHT I WAS lost
.
how do you know you were there
.
I was there in the void
.

darkness buzzed like potassium in water
the whole night, the minute by minute
fuzzed in the gut with the crow of it
.
I longed for transparency by numbness
you thought you were lost
.
was our dinghy built by a child, a toy
bright as strawberry
.
you thought you were lost
we were squashed in like a sixth toe

I had no inkling in this night our destination
our families had coughed up the silver for these
 machete men
they took us from the Jungle by knife in the neck
 I prayed my bones to go

 who were you we were strangers to each
 an old woman slumped in the midst of our boat
 she was shut like a past tense
 the stalks, the petals of her dress
 appeared she was held under irony

how do you know you were there

 the waves were the Zagros mountains
 come from my homeland

 I was oompah to the impressive percussion
 when water kept clanging alarm bells
 in my nerves

 I twitched my headspace for a quiet
 that candles the underbelly of a racket

 when the gut by bile has been scraped
 how thick is the last line of undercoat lining the gut

 how do you know you were there
it's over a year & I carry the night-time on my face
 my eyes the survivors of a drowning
 if I unzip my face
 when it isn't flooding in
 salt floods out

THE DISSENTER'S TALE

.
what did you learn the ocean's a colonial bludgeon
 .
 what did you learn
 refugees reach a Best Buy date
 when the broken slate of international law bobs
 embodied like blots on the Channel

 .
did you cry I cried someone help Justice
 she bleeds from the eyes
 .
I heard my Master's degree in History
 like water falling out
 from the windows of my ears

 .
I held my breath my breath would not let go
I held my breath my breath would not let go
 .
I remember the Revolutionary Guard
 would come for me to hood me, beat me
 till I crumbled like salt

 .
 why would a Kurd become a political animal
 why would a Kurd become anything at all

 .
 .
then a light arrived then a boat rescued us
 you thought you were alive
 I was being rescued
 .
in my sea change, I was turned into a clown
if I walk the yard I invite laughter
 with these enormous clothes gifted me
 these shoes where my feet are at sea

.

 if I seem ungrateful I'm not in my voice
 the more I studied the more my voice
was being erased

 .

 excuse me! this is no lockup, container, cell or prison
 you are in the master's mansion & you gad from one
 to another of his abodes at hours of the night
& we feed you like a king with a salver of white bread & crisps

 .

 hear the wax paper rustle extravagantly
as the fragrance of margarine effluences under your nostrils
 the smell of a diet fit for a diet

 .

what did you learn the aesthetic migrants reside in
 is attrition thinned to biting a thin sandwich
sensual hardship which even this poem cannot diminish

 .

 .

what did you do I went on hunger strike
 I thought they would hear me
 did they hear you
 their eyes were empty

.

I wore my throat on the outdoors, then at the garden gate
 still, no one saw my pain

.

 has someone made them make me sit here
their silence is a boarded window
 should I pity them

 .

some nights, who's lit a match upon my diaphragm
so the smell smoking through me's a pyre in the neck

 .

what do you know the phonelines to my mother

THE DISSENTER'S TALE

 are waxed with ears

 .

 is there a happy ending
 now we must come to the ending

 .

 is it because I'm brown as a mullah
 that my beard might be a keg of secrets

.

what do you know I'm a pest wherever I nook

.

my pitch, I have doughball manners, I'm a handy factotum
set me a task & watch my monobrow lower itself
like a brush that clears away all misapprehension

.

my pitch/ I'm firm as prison bars/ I can bounce inside my traumas/
my fingers would never reach beyond the bars/

 .

 is there a happy ending
 a year on & my application has not been registered
 a year on & I'm in a queue stretched
from Dover to a cloudy door above London
whose handle will not lower for me

 .

 I thought they would hear me
 you thought you were lost

 .

once I may have been the voice of your conscience
you may have watched me perform my thank you

deportation is a lift-off toward a hanging

 .

 how do you know you are here
 by virtue I am not here

 .

 is there a happy ending
 there is always a happy ending

 .

 I feed my time on your books
 to see where your words will leave me

 .

my head, by its own accord, holds a basket
 where scarlet fruit is taken & given

The Businessman's Tale

as told to
Haifa Zangana

MY JOURNEY FROM BASRA to London started five years ago.

I was born into a well-off family in Basra, the oil-rich city in the south of Iraq. My father was a manager at an oil company who refused to leave Iraq during the turbulent decades from the Iraq-Iran war (1980-1988), to the first Gulf war in 1991, and the UN sanction years (1991-2003). Even after the occupation of 2003, none of us thought of leaving Iraq.

In the eighties, during what's called the War of the Cities, we survived Iranian air raids, missile attacks and artillery shelling on Basra – a day-and-night, nonstop bombardment. Students were often asked to leave school and go back home. We were told, it's safer there. In our two-floor house, we had to sleep in the courtyard for fear of being buried under the collapsed roofs. Once, we had a bomb explode in our house. Thank God we were not there then. Until now, whenever I hear a sudden sound, I start to shiver as if I have a fever.

In the nineties, in 1991 and 1998, we survived the US-UK campaigns of bombing, and the harshness of the years of imposed UN sanctions when people were reduced to selling

their belongings and getting multiple jobs in order to earn enough to feed themselves and their family with dignity. I myself, like many Iraqi youth, had to work after school to help my family survive. Then came the invasion and occupation in 2003 and we had to put up with the utterly disastrous consequences. Can you imagine what kind of life we had over the years? It's not just me, of course. From childhood to adulthood, all of us had been living under the brutality of wars and sanctions.

Despite all that, I studied, graduated, worked, established a private business, married and had my children in Basra, the same city in which my father and grandfather and great grandfather were born, worked, married and died. After gaining my diploma from the Institute of Industry, I served in the army, worked and in 2005, I opened a toy store selling imported toys from China. It proved to be a successful business.

We were an ordinary family, that chose to stay in the same city no matter how difficult the circumstances, trying our best to lead an ordinary life, until the not very ordinary day when my seven-year-old son was kidnapped. In 2018, while he was on his way home from school, he was kidnapped by a notorious Iranian militia, famous for its members' drug trading and consuming. They demanded a ransom of 100,000 US dollars.

On that day our life changed forever. For five days, we as a family lived in hell. His mother, my wife, had a stroke which left her in need of long-term treatment and rehabilitation. All I was thinking about was how to pay the huge ransom. I was trying hard not to think of what might happen, firstly if I couldn't raise the money, and secondly if the kidnappers might kill my son after getting the ransom. What happened to so many others is that ransom demands have frequently been made even though the person kidnapped has already been killed.

THE BUSINESSMAN'S TALE

The minutes became hours and hours turned into days. Fear and imagining the worst almost paralysed me. Waiting. Waiting. Waiting for instructions on how to deliver the money. On the fifth day I did. I gave them all that I had worked hard to earn for 20 years.

Thank God, they released my boy. I could not believe my eyes. Seeing him alive and hugging him, I lost control of myself. I cried like no man cried before. Until now, the shock is here as a part of me. I often wake up terrified during the night. I have to try to convince myself it's only a dream and my son is with me. He is safe. There isn't a night I sleep peacefully. The fear I feel is rooted inside me. A physical ailment would have been visible, but shock is not: it is an invisible wound.

Though I could not comprehend what was happening after the kidnapping, I felt that everything was indicating that this is not the end of our suffering. I saw the rapid mushrooming of the militias in the last decade, and how they are growing more powerful than the government, while we, the defenceless ordinary people, had to pay whatever we are asked to in order to spare the lives of our loved ones. I came to realise that the kidnapping of my little boy was only the beginning. The militia planted fear in my heart about my whole family. They knew everything about us. They knew I was doing well in my business so another attempt would be made. So I was forced to accept the idea that I and my father before me had always refused to accept. I had to accept the painful idea of leaving my family, my relatives, friends, work, city and country.

Embarking on the journey was not a matter of choice. It was certainly not for the £40 weekly income support I have been given here to live on. It was an acceptance of an alternative solution born out of extreme necessity. It was a forced migration. Who on earth would think of leaving his family and prosperous business to venture into a perilous

unknown journey with a seven-year-old child? Why? How can anyone think of depriving a child of his mother's love unless it was to save his life?

Would you?

Shall I tell you the details of our journey? All the details? The route, the dates, and the cost? It's a long story of a journey that lasted five long bitter years and counting. We are still in limbo, not knowing when we will reach the final station. Or whether will we ever reach it.

I won't delve into the difficulties and inhuman treatment we faced along the route. The cold weather, the sleepless nights, the long walk, the beating by border guards and police. I will tell you that later. I am going to see you later, right?

I will stick for now to a short summary of the dates and places we went through to reach Britain. How do I remember the dates and the places? Well, they are engraved in my memory. When I am asked, all I have to do is to close my eyes and pick them up.

It was on 25th April 2018 that we flew from Basra, our city, in the south of Iraq, to Istanbul. We reached Germany, our final destination or what we thought was our final destination, on 3rd June 2018.

Throughout the journey we were pushed from one means of transport to another: by coach, from Istanbul to Izmir city, where we spent two days, to the seaside resort Marmaris where we stayed for three days, then by boat to the island of Rhodes in Greece and then another boat to Athens.

Then it was by car to a place near the border with Albania, then we walked into Albania. We began walking on the evening of 12th May until the morning of the 14th. We were not alone. With us were a number of families including children. We paid a fortune to have a place in a car heading to Tirana where there is a refugee camp. But it is a camp unfit for human beings. We stayed there for one day during which we managed to have a shower and wash our clothes.

THE BUSINESSMAN'S TALE

Then we were off by bus from Tirana to what was supposed to be Montenegro. But we were dropped off after a while to continue the journey by taxi to the border. Then we walked for 24 hours until we got to a railway track. Follow the railway track, said the smugglers. Confused and disoriented we had no choice but to comply. At this stage of the journey we had with us young Iraqis from Fallujah city, in the west of Iraq, and women and children.

We had no energy to argue or question the smugglers, we just walked along the train track not knowing where we were going. We were all exhausted, especially the children. Finally, we reached a camp in Montenegro where the officials took our fingerprints and were kind enough to give us a map. Waiting for the next move we stayed in the camp for two days. Waiting became part of our existence.

We took another taxi to the border of Bosnia. Then we walked from the morning until midday the following day. The Bosnians were kind. They gave us bread and dates because it was the 1st day of Ramadan - 13th May 2018. We stayed for four days in Kosovo. Then a taxi driver charged each one of us 1000 euros to take us to a place near Slovenia's borders. We had to hide in a field from 5am until 2am the next day. It was very cold at night and we were attacked by insects, but we had to keep completely still and quiet in order not to alert the border patrols guards. At 2am we started walking until 11am when we were in Slovenia. At a camp there, we spent the night.

The next day, we left for Italy. We spent the night in Milan. In the morning, we left for the German border by car and then by train to Bochum city in western Germany where we were received kindly.

We arrived on 3rd June 2018, a date we imagined would be the end of our journey. It was not. The German authorities moved us to a camp in Unna city in North Rhine-Westphalia where we were treated as subhuman. I remember very well how they were reluctant to give us some second-hand clothes

and shoes. On 25th 2018 June I was interviewed by two immigration officers. I showed them our Iraqi passports, my graduation certificate, my son's birth certificate, photos of my family etc. I handed over all the Iraqi official papers that prove our identities. I showed them in particular how well travelled I was on my business trips from Lebanon to China. In February 2019, my application was rejected. Without legal assistance I had to pay a solicitor to appeal on my behalf.

For three years, we were kept in a tiny caravan room in a camp in inhuman conditions. I wasn't allowed to work though I was dying to work. I was doing nothing. Just waiting. Stuck in the land of void. Facing an uncertain future and the fear of being sent back to Iraq. On the verge a of nervous breakdown, I decided that I couldn't take what felt like a death sentence anymore. Had the German authorities allowed me to work, and if my son could have had a proper education and if we were living like human beings, I would not have ventured on another horrific journey risking my son's life and my own.

So, on 30th March 2019, we embarked on another journey. This time by boat to Britain via France, hoping for an end to our suffering. We were in Dover on 1st April 2022. While we were rescued, we were told that we should leave everything we have aside. I left my backpack behind, the one that I carried with me through my whole journey from Iraq to Germany to Britain. It contained all my Iraqi documents: our passports, birth certificates, graduation certificate, my marriage certificate etc. You will get them back later, we were told but we never saw it again. I kept saying, 'my backpack', 'my backpack', to no avail. When I met a lawyer later, on the same day, in the presence of an interpreter, they recorded my interview and I kept asking for the backpack. What's happened to it? Was it given to someone else by mistake? How can this be since it contains all the key identity documents with my photo and my son's photo? Haven't they stored what we were told to leave behind or have they just got rid of them? How

THE BUSINESSMAN'S TALE

could they? How can we prove our identity? I feel as if I have been stripped of it, while at the same time not offered an alternative.

We were accommodated in a room in a hotel. Waiting again. After four months of waiting, in a dark moment of despair, I thought we can take the bus back to Germany. At the UK border I was arrested. I told the officials I am not escaping. I haven't committed a crime. I was told that my papers for the UK are alright so I took the bus. They thought I was lying. They took my son. I was sentenced to six-and-a-half months in Brook House immigration removal centre. I was supposed to be released from prison on 22nd Feb 22 but was not released until 20th June 22. They claimed that they could not find a place to re-house me. So I spent an extra 122 days there.

For almost a year, I wasn't allowed to see my son. The social workers took him. I was only allowed to talk to him by phone, for 20 minutes, every two weeks and I had to have an interpreter so they could record our conversation. That meant, we only had the chance to talk for 10 minutes. By the time I asked him how are you, and he cries in reply and I try to calm him down and console him saying that all will be alright soon and the interpreter interrupts our miserable exchange, the 20 minutes would pass leaving both of us in tears. We both have been destroyed psychologically. I can see the effect of the trauma clearly on my son. Whenever someone knocks at our door in the evening, he panics saying, 'They're coming to take me.'

In Brook House, what can I say? It's not a house. It's prison. We were not treated as human beings. We were subjected to inhuman, degrading conditions. No respect. I found myself in an alienating environment, where the detainees' screams, the noise, the general hysterical atmosphere, and frustration combined with headaches were about to drive me mad. When I asked for paracetamol tablets, because my

head was about to explode, I had to wait six hours to get them. In general, the only medication you are prescribed is paracetamol, anti-depressants and sleeping pills. They make you feel like a zombie. You are there and not there. Engulfed by anxiety you lose your sense of reality.

In the midst of all that, they brought me a psychological counsellor. Are you upset? She kept asking me. Why are you upset? Are you bored? I said how can I not be upset when they took my son? How can I sleep? How can I stop thinking of him? Of our whole situation? Put yourself in my place. How do you feel when you go home after a long day at work, don't you feel happy when you see your children? Don't you forget your tiredness? I used to feel happy, not upset and relaxed, not bored, when I got home and see my family.

What about now? The future? We are still in the same situation as we have been in the last five years. Waiting to get the permit to stay. My son, thank God, is doing well at school and I am attending English language classes. My greatest hope is to be allowed to work, to support myself and my son. To regain my dignity. I want to work, not to live on support. I have been working all my life and earned my living myself, never relying on charity. This is not how I have been brought up.

Do you know what it means to just wait, not knowing if you will be allowed to stay and settle, or forced to leave not knowing where to go? Do you know what it means to wait for days, months, years for a phone call or an e-mail to let you know what is going to happen to you? Do you know I never move anywhere without my mobile for the fear of missing that phone call?

The future?

Now, waiting is our future.

The Friend's Tale

as told by
Ridy Wasolua

As we approached the Spanish border, a sense of hope mixed with apprehension swelled within me. The journey to this point had been a test of endurance and courage, and the promise of a new beginning beckoned on the horizon. Yet, as the border came into view, a stark reality emerged – one marred by hostility and prejudice.

Hostile glares and harsh words were flung at us, the weight of racism and ignorance casting a shadow over the prospect of safety. The boat that had carried us through the tempestuous waters was met with disdain, as if the trials we had faced were somehow a reflection of our worth. As I stood amidst the chaos, echoes of the past reverberated – the memory of rebels wielding weapons – a stark reminder that danger can take many forms, even within the confines of supposed refuge.

Amidst the sea of faces, I clung to the thread of my own resilience. The officers and guards, their weapons poised, were a chilling tableau that mirrored the threats we had fled. Yet, I refused to relinquish hope. The journey had taught me that there are pockets of compassion and understanding even in the darkest corners, and I was determined to find them amidst

the hostility. The transition from the boat to the larger ship was marked by a heavy sense of disillusionment. As the handcuffs clicked into place, the very authorities who were meant to protect became agents of confinement, their ship a vessel of both transport and containment.

Seated in silent rows, we stared out into the expanse of the sea, a sea that once held the promise of a fresh start. The cuffs on our wrists seemed to cut deeper than the metal itself while the commands to remain still, to sit without movement, felt like a decree that extended beyond the physical restraints – it was as if we were being told to resign ourselves to a fate beyond our control. In the midst of this desolation, a glimmer of humanity shone through. Though bound by metal, the bonds formed between those who shared this ordeal were forged by empathy and solidarity. We leaned on each other for support, offering words of comfort and solace. The transition from the ship to the imposing building was a journey into the unknown. As we were led, one by one, with our handcuffs still binding us, a sense of unease settled in the pit of my stomach.

★

The interior was a labyrinth of halls and rooms, each one cloaked in shadow and uncertainty. The purpose of this place remained shrouded in mystery, a looming question mark that hung in the air. As we were seated, one by one, a procession of procedures began – a series of measures aimed at extracting our identities and histories. Fingers pressed onto sensors, images captured, swabs taken, as all the while a sense of vulnerability deepened.

The warmth of the clothing they provided was a contrast to the chill of apprehension that clung to us. Questions were posed, their intent clear, even if the specifics eluded us. We were trapped in a liminal space, caught between hope and uncertainty, struggling to understand why the sanctuary we had sought seemed to double as an interrogation room. The

lack of a translator was a glaring omission. My name, my origin – they became pieces of a puzzle I couldn't put together, and as they handed me a paper, their insistence that I sign it echoed in my ears. The pen felt heavy in my hand, as if the ink carried with it a weight that I couldn't comprehend. I placed my signature upon the paper, a mark of acquiescence fuelled by a desire to move forward, to escape the stifling grasp of uncertainty. Only later would I understand the gravity of that decision, the cost of signing away a piece of my autonomy in exchange for the semblance of progress. The directive from the white man to leave the room carried with it an air of dismissal, a further reminder that I was merely a piece in a larger puzzle, moved and positioned by hands beyond my control.

The rooms we were ushered into bore the hallmarks of a foreign landscape – one that bore little resemblance to the familiar settings of home. Metal doors, locks, and the stark reality of confinement painted a contrast to the vision of safety we had held. The cell they placed us in was an embodiment of harshness – an intimate space where four individuals were confined, their futures uncertain. The question, 'Is this what Europe is like?' echoed within me, a question born of disbelief and a collision with an unanticipated reality. As night descended, the chaos and cacophony grew. The screams and the banging became the backdrop to our thoughts, a haunting chorus of voices lost in a place of uncertainty. Sleep was elusive. The turning and tossing mirrored the turning of my thoughts, grappling with the enormity of the journey I had undertaken.

The weight of grief for the friend lost a long time ago in the river mingled with the overwhelming fear of the unknown. The contrast between surrendering oneself for a better life and the current reality was acute – a paradox that I struggled to reconcile. The disillusionment grew, and a pervasive sense of vulnerability took root. The dream of safety

had twisted into an unsettling nightmare. The passage of time in that confined room became an agonizing rhythm, marked by the relentless monotony of days blending into one another.

The hour we were granted for outdoor respite felt like a fleeting moment of freedom; the walk in the yard, a temporary release from the oppressive atmosphere of the room. But as the minutes ticked away, we were once again ushered back into the place that had become our temporary home. The routine etched itself into our minds with unwavering predictability. The hour in the yard, the line for meals, the consumption of food, the return to the room – it was a series of motions that became a grim dance, a dance of survival rather than of joy. The absence of visitors, the silence of explanations, and the echoing absence of a translator deepened the sense of isolation. We were left adrift in a sea of uncertainty, navigating the current of confusion without a guiding hand.

With each new sunrise, hope flickered, only to be replaced by the same routine, the same confinement. We were left to grapple with the questions that plagued us – what was happening beyond these walls? Were our fates decided, were we trapped in this liminal space indefinitely? The waiting was both a test of patience and a testament to the human capacity to endure. We were suspended between the past and the present, between the hope we had clung to and the reality we faced. The uncertainty was a weight that bore down upon us, a weight we carried together, in the collective experience of those who shared this ordeal. As dawn broke, a simple knock was enough to jolt me from the restless slumber that had become the norm. The arrival of the translator was a glimmer of clarity amidst the confusion that had enveloped us. Their presence bridged the gap between languages, offering a lifeline to understanding, while the officers' questions were a reminder that the path to resolution was paved with the necessity of sharing our stories.

As the interrogation unfolded, I recounted the journey

that had brought me to this foreign land. The blindfold that had obscured my surroundings, the nameless guides who had directed my steps – it all flowed from my lips, a narrative of uncertainty and dependence on the guidance of unknown faces. The interview was a process of repeatedly affirming that my actions were driven by the instinct for survival rather than any malicious intent. The relentless questioning eventually drew to a close, and with it came a mixture of emotions – relief mingled with exhaustion as the weight of the interrogation lifted. The prospect of being transferred to a shelter, a haven of respite, seemed like the next logical step in this journey toward understanding and acceptance.

However, the reality that followed was a brutal departure from my expectation. Instead of finding shelter, I found myself released, thrust back into the world with the responsibility of reporting to the station in two weeks' time. The journey through the gates, one after another, was a surreal march towards an uncertain destiny. Standing outside, bag in my hand felt foreign, a reminder of the possessions I had carried with me into this journey. The reality of my newfound freedom was disorienting, the sensation of liberation juxtaposed with the disarray within my mind. I was left standing there, an island of uncertainty in a world that remained both familiar and alien.

★

The arrival of fellow travellers echoed the collective experience we had shared. The decision to navigate this unfamiliar terrain together was a testament to the resilience that had carried us through our individual ordeals. The landscape before us was a tapestry of beauty, a stark contrast to the turmoil that had defined our recent past. Left to navigate the uncharted territory of a foreign land, I found myself grappling with the reality of my situation. As I sat on the pavement in front of the station, the weight of my circumstances pressed down upon

me. Numbness replaced coherent thought and I stared out into the darkness, the world around me both alien and incomprehensible.

Lamp posts cast a feeble glow as passers-by moved in hurried silhouettes. Overwhelmed, I closed my eyes, seeking solace in the darkness behind my eyelids. Amidst this disarray, a presence materialised beside me, a figure that cut through the haze of confusion. His voice, like a lifeline, reached me in a language I understood. His inquiry about my name was both unexpected and soothing. The words he uttered, 'I have been expecting you,' and the nickname 'sugar,' were both puzzling and oddly comforting, a reminder that in this vast sea of the unknown, there were still mysteries yet to be unravelled.

As I looked up, the man's familiarity with my language was a bridge between my fractured reality and the world I had left behind. The act of following him was a leap of faith, a decision to embrace the unknown with a shred of hope. Together, we embarked on a journey whose destination remained uncertain, the path unfolding step by step, the language barrier momentarily breached by the connection of shared words. He sought to understand what fragments of information had been shared with the authorities, what had been revealed in the midst of the interrogation. My response echoed the truth – I had only followed the route that was laid out before me, my actions driven by the elusive dream of a better life.

Our path eventually led us to a grand house. The very word 'house' conjured images of stability and shelter, a sharp contrast with the transient existence I had known since embarking on this journey. Yet, the basement – the location I was directed to – carried with it a sense of enigma, as if even within these walls, mysteries lay in wait. As we descended into the basement, the air grew cooler, and the surroundings became a canvas of shadow and light. The man's declaration that this was to be my temporary abode triggered a mix of

emotions. The prospect of an encounter with their boss hinted at a future that held both promise and uncertainty.

The man's next action was to blindfold me. Deprived of sight, I was left to rely on my other senses – an exercise in surrendering control. As the minutes ticked by, I found myself at a crossroads of emotions. Fatigue tugged at my consciousness, yet a spark of curiosity and determination still glimmered within. In the presence of the boss, the weight of my journey and the trials I had overcome were acknowledged. His congratulatory words held a mixture of respect and acknowledgement of the challenges I had faced. It was a reminder that the path I had undertaken was no small feat, that the very act of making it this far was an accomplishment to be recognised. Curiosity led me to inquire about the other survivors – the individuals who had shared the same arduous journey. The response was a gentle redirection, a suggestion to relinquish interest in the fate of those left behind. The boss's presence carried with it a certain authority, a figure whose influence had shaped my path. His assertion that I owed my presence in Europe to his intervention was a measure of the interconnectedness of the journey, the threads of influence that had been woven together to bring me to this point. The future he painted was a canvas of labour and permanence. The mention of working for a 'long time' hinted at a commitment that extended beyond the immediate horizon.

The room, spacious yet empty, mirrored the vast expanse of possibilities that stretched before me. The space held the potential to become a haven, a place where I could carve out a semblance of stability amidst the turbulence of my recent past. The room's bareness held the promise of transformation – a promise that, over time, the emptiness would be filled with life and the echoes of my presence. The bed offered a temporary respite from the journey's trials. As I lay down, a mixture of disbelief and sorrow washed over me – sorrow for the friend I had lost, a friend, Kobacka, who had become a

piece of my heart, and disbelief that my journey had led me to this place of both opportunity and uncertainty.

Drowsiness eventually pulled me into a light slumber, but the footsteps that roused me from my sleep triggered a swift awakening. The man in the suit who entered was a silhouette in the low light, and a sense of respect, ingrained from my culture, prompted me to rise to my feet. However, the aura surrounding him – the smirk, the gradual removal of clothing – gave rise to a sense of unease. The dread that unfurled in me was not unfounded. The man's intentions became painfully clear, and a wave of disbelief and horror washed over me. My instinctive reaction was to raise my voice, to question his presence, to assert my boundaries. Yet, even in that moment of vulnerability, my courage wavered as the realisation of the situation I had found myself in sank in.

The man who had picked me up before intervened, his appearance like a guardian of this dark encounter. His words shattered any hope I clung to – the idea that this was an aberration, an anomaly in the narrative I had crafted for myself. His words laid bare the truth – a truth that felt like a betrayal, a revelation that my friend, the one I had entrusted with my dreams, had orchestrated my placement in this nightmarish scenario. The pain of betrayal mingled with the reality that I was trapped, caught in a web of manipulation and desperation. The prospect of resistance, of reclaiming my agency, was crushed by the weight of the consequences that hung over me.

The days that followed marked a descent into a harrowing abyss – a reality where my sense of self was eroded, and my spirit was broken. What unfolded was a relentless cycle that stripped me of everything I held dear – my dignity, my faith, and my very essence. The experience was a numbing assault on both body and soul, a relentless barrage that shattered any semblance of normalcy. The violations, repeated countless times each day, were a brutal reminder of my vulnerability.

THE FRIEND'S TALE

Each instance carved a deeper wound, leaving an indelible mark on my psyche. Weakness seeped into every fibre of my being, my spirit weighed down by the burden of what I was enduring. Sickness, both physical and emotional, took root, its tendrils winding around my every thought and sensation. The perversion of what had become my reality never ceased to disturb me. What had once felt utterly wrong eventually morphed into a twisted sense of normalcy – an acceptance born not out of willingness, but of surrender. The dichotomy between the fundamental wrongness of the situation and the desensitisation that followed was a testament to the extent of my trauma.

Appetite waned as the ordeal continued, my body betraying me in its refusal to partake in sustenance. Panic attacks became a morning ritual, their grip tightening around my chest, a physical manifestation of the emotional prison I was trapped within. The weariness I felt extended beyond the physical realm, pervading my spirit with a heaviness that threatened to engulf me entirely. The dreams I had carried with me had been reduced to mere ashes, scattered in the relentless gales of despair.

*

The turning point in this odyssey arrived with a new layer of deception – the forging of someone else's identity to secure passage into the UK. A passport with my image on it offered access to a new land, a new chapter, but the very act of boarding the plane was a symbolic severing of ties to my past. The instructions to destroy the passport, to eliminate any traces, were followed with a heavy heart and a weighty understanding of the irreversible step I was taking.

As I arrived at immigration in the UK, the façade began to crumble. The act of facing authorities with no legitimate identity was a sobering confrontation – the questions they posed, the scrutiny I faced. But the sense of being damaged, of

enduring profound abuse, was a feeling that eclipsed everything else. The pain of the ordeal, the emptiness that had carved its niche within me, was a reality that overshadowed the immediate situation. As they led me to an immigration holding centre, the transition marked another step into the abyss, a continuation of the tumultuous journey that had marked my life. From the holding centre, the journey carried me to Brook House detention centre – a place of uncertainty and shared despair. The faces that greeted me were a tableau of lives disrupted, each one bearing the weight of their own story.

The detention centre, with its barred windows and confined spaces, mirrored the entrapment of my spirit. Yet, amidst the misery, glimmers of shared humanity persisted. Each individual harboured their own story, a narrative marked by the intersection of survival and desperation. The misery that hung in the air said clearly that this was a place of limbo, a space where people were caught between the dreams they had chased and the unforeseen realities they encountered.

The first two nights within the detention centre were a plunge into the unfamiliar, marked by discomfort and a deep sense of disorientation. As time moved on, the passage of two years saw me acclimatise to the environment, although I could never bring myself to label it as home. The detention centre, despite its grimness, became a space where a twisted sense of familiarity took root.

Nighttime within the centre was an exercise in collective unrest. Detainees, fuelled by substances that were an attempt to numb their circumstances, unleashed their agitation on the doors, creating a symphony of distress that reverberated through the space. The aggression was both a testament to their struggle and a coping mechanism – a volatile orchestra that underscored the desperation that was shared, yet uniquely experienced.

Sleep became elusive within this tumultuous soundscape. In

the darkest hours, questions began to haunt my thoughts – why was I confined? What had I done to earn this fate? Alienation seeped into my consciousness, a pervasive sense of not belonging, of not being deemed worthy. The option of ending my own life, a manifestation of the darkness that encircled me, found its way into my thoughts. Yet, amidst the bleakness, I clung to distractions that provided temporary reprieve from the abyss that beckoned. It was a battle to stay afloat, to resist the pull of despair that threatened to consume me entirely.

My identity, my essence, had been chipped away by the relentless series of trials I had endured. The last vestige of who I was – my voice – was slipping through my fingers. Even when I spoke, the sensation of being unheard persisted, a reflection of the isolation that had become my reality.

Contacting a solicitor, a glimmer of hope in the fight against my confinement, was an unattainable goal. The language barrier and lack of external support meant that this lifeline remained out of reach. The walls that surrounded me were both physical and metaphorical, trapping me in a world where advocacy and assistance were beyond my grasp. From the vantage point of the landing, I observed the diverse spectrum of humanity that populated the detention centre. Each individual carried a story – tales of displacement, desperation, and dreams deferred. As I watched, the detainees moved with a mixture of restlessness and resignation, navigating the confines of their existence within those walls. The detention centre, with its austere architecture and confined spaces, served as a microcosm of the larger struggles that had driven us all here.

There were moments of camaraderie – shared glances, unspoken understanding – that bridged the gaps of language and origin. And yet, the undercurrent of frustration and yearning remained palpable, a constant reminder of the lives that had been disrupted and the aspirations that had been dashed.

From the landing, I could sense the tangled web of emotions woven through the detainees' lives. It was a mosaic of resilience, heartache, and hope that painted a vivid portrait of the human spirit's ability to endure – even within the confines of adversity. The descent into that moment of overwhelming panic was like a plunge into a dark abyss. My body's betrayal, the sudden weakness and constricted breathing, felt like a seismic rupture within me. The pain, both physical and emotional, surged through my being like an electric shock. It was as if I were a spectator to my own suffering – a disembodied witness to the turmoil that was unfolding. The feeling of being trapped in an out-of-body experience was disorienting, a sensation that severed the connection between my consciousness and my physical form. My thoughts raced, and my senses were heightened, every detail of my life playing out in rapid succession. The village, the journey to England – all of it unfurled before me, like pages flipping in a book. The most agonizing chapter was the one that chronicled the abuse, a reality I had tried to shield myself from. Yet, in this moment of vulnerability, those memories clawed their way to the surface, unveiling the raw wounds that had been hidden beneath the surface. It was a torment I had to confront, a pain I had to process even as my body seemed to betray me.

In the midst of my distress, the people around me rallied. Their presence, though blurred by the haze of my panic, was a reminder that I wasn't alone in this struggle. But even their support couldn't stem the torrent of emotions that had been unleashed. Amidst the chaos, I thought I caught sight of Kobacka on the landing. The pain I felt, the anger that coursed through me, manifested in a primal shout – an instinctual cry that reverberated through the air. But my body's weakness left me unable to follow through on the urge to confront him physically.

Officers intervened, their presence a counterpoint to the maelstrom of emotions. Their attempts to calm me, to steady

my ragged breaths, were met with a struggle that felt insurmountable. My heart raced, my chest tightened, and the desperation for reprieve only seemed to intensify the sensations that threatened to engulf me.

As the chaos continued to unfold, I was carried away from the tumult, placed in a holding room by the officers. The room became a cocoon, a temporary sanctuary where I could attempt to regain some semblance of control over the torrent that had consumed me. Lying there in the holding room, the weight of the tumultuous episode still pressing on me, I felt like a shell of my former self.

My cell mate's approach, his inquiry about my well-being, was a gesture of camaraderie in a place where camaraderie was scarce. His observation that he had never seen me in such a state was a testament to the facade I had maintained, the front that had cracked in that moment of crisis. The tears that escaped my eyes, unbidden and raw, were an outward manifestation of the pain that had been simmering beneath the surface. The words that followed – a confession of my exhaustion, of my surrender to battles that had grown larger than life – held the weight of defeat. It was a cry from the depths of my being, a desperate plea to release the burden that had grown too heavy to bear.

The exhaustion I spoke of wasn't just physical weariness; it was a weariness of the soul, a weariness that had settled into the marrow of my bones. It was the weariness of fighting against currents that seemed insurmountable, of grappling with forces that defied comprehension. The battles I had fought were more than just external struggles – they were battles within, battles that had corroded my spirit and left me adrift in a sea of confusion and despair. In that moment, lying there with my cell mate's gaze upon me, I confronted the reality that sometimes the strongest thing we can do is admit our vulnerabilities. The facade of strength that I had clung to was stripped away, and in its place was a raw authenticity – a

glimpse of the unfiltered truth of my emotional landscape.

Amidst the desolation of the detention centre, the presence of my cell mate emerged as a beacon of connection. His willingness to bridge the gap, to reach across the chasm that separated us, was a testament to the resilience of human empathy. The language barrier, though a challenge, was not insurmountable. Instead of allowing it to erect walls between us, my cell mate chose to dismantle those barriers brick by brick. His efforts to communicate, however imperfect or fragmented, became a lifeline – a thread of understanding woven through the tapestry of our shared experiences. Appreciation for his companionship bloomed from the seeds of mutual support. Through gestures, expressions, and whatever vocabulary we could piece together, we found a way to forge a connection that transcended the limitations of language. In a space where despair often reigned, my cell mate's efforts assured me that even in the darkest corners, the light of human connection could still shine – that compassion was a universal language, and that in our shared struggles, we could find common ground.

★

The news of my cell mate's imminent release, after enduring eighteen long months within the detention centre, delivered a sharp blow to my already fragile equilibrium. His presence had been a source of solace, his wisdom and companionship a steadying force. The trust I had placed in him was not taken lightly, and his departure left an emotional void. It felt like a continuation of the pattern of loss that had punctuated my journey – a pattern that had begun with the death of Kobacka. The departure of my cell mate, even though I felt a genuine happiness for his newfound freedom, accentuated the isolation I felt. It was as if the threads of connection were being severed one by one, leaving me adrift in a world where trust was scarce and companionship fleeting.

Despite the physical separation, the fact that he continued to keep in touch was a testament to the resilience of the bond we had formed. The connection we had shared, though no longer grounded in proximity, still had the power to transcend the barriers that confined us. In the ebb and flow of transient relationships within the detention centre, his continued correspondence told me that the connections we make, no matter how brief, can leave lasting imprints on our journey.

The morning that brought a letter from the Home Office was a mixture of trepidation and anticipation. The summons to their office was a summons to face the bureaucratic machinery that held the power to shape my destiny. Arriving at the appointment, I was met by their representatives, accompanied by a translator – an intermediary bridging the gap between my words and their understanding. The questions they posed were direct, their inquiries a spotlight on my circumstances within the detention centre.

'Why haven't you applied for bail?' they asked – an inquiry that laid bare the procedural options that had been available to me. In the face of their question, I offered my explanation – a frank admission of my lack of family or friends, and the reality of my financial destitution. The mere thought of seeking legal representation, of navigating the complex terrain of solicitors and legal fees, seemed like an insurmountable hurdle. My words were an articulation of the helplessness that had become a prevailing theme in my life. The concept of living on the outside, unshackled from the confines of detention, felt like a distant dream. The barriers I faced were not just bureaucratic; they were existential. How could I reintegrate into society without resources, without a support network, without even the assurance of a roof over my head?

The encounter with the Home Office, the very institution that held the keys to my freedom, brought home the terrible asymmetry of power that governed my circumstances. The

vulnerability that had characterised my journey was now mirrored in this interaction – a microcosm of the larger struggle I faced in asserting my humanity within a system that seemed indifferent to it. As I navigated the labyrinthine challenges of my situation, the encounter with the Home Office became another chapter; a chapter that underscored the complex interplay of personal agency and systemic barrier; a chapter that resonated with the broader themes of resilience, desperation, and the pursuit of a better life.

The Young Man's Tale

as told to
David Flusfeder

I WAS BORN IN THE late 1990s. Since 2020, I've been in this country.

I'm from Darfur. The village we lived in was being attacked by the militia of the government. Normally when they attack they come in the morning, 6am or 7am or even 4am, when people are sleeping, they attack the village from all sides. Most of the people, they're going to get killed.

Suddenly you wake up at 7am, and there is gunfire everywhere.

Our village, I remember, in 2008 they came and attacked from every side. Many people, they died. I was just ten years old, but I remember.

And the second time they attacked the village, my father was killed. My uncles, seven of them, were killed.

I was with my mother, and my brothers and sister, who are younger than me. We have to leave the village because they're going to burn it totally. We left, nobody is coming back to live there.

Because of the war, since I was ten we lived in a refugee camp. It was established because there are people in other

parts of that region who have fled because they were attacked. Around the city of Nyala there are five camps. The camp we lived in is on the east side.

UNICEF gives you a tent. Save the Children, Oxfam, they support us. Some of them provide water, some of them food. Red Cross for when you are ill. UNICEF have English classes.

It is one of the biggest camps but the government attacked it several times. The government militia, which is called Rapid Support Forces. Before that they were called Janjaweed. When I was there there was a big attack, August? I don't remember the day exactly. They killed many many people. They killed 112 and injured more than 200 people.

My family is still there. My brothers and one sister. Sometimes I have contact with them but it is difficult because internet is not provided there. Since 2004 there are some people who have not been outside the camp. At any time, the militia might attack. It is dangerous in the camp. But you cannot go outside the camp. If you go to the city, it is dangerous. When I go there, they stop, they are asking me, 'What's your tribe?'

If I get a bus or a lorry, it's 40 minutes to the city, but the militia, they're looking for you inside the lorry. They see us, all the people who live inside the camp, they say we support the opposition.

This happened to me one time in 2015. I was coming to the city, they stopped the lorry, and they were asking me, 'What is your tribe?' This is the most common question they ask. The people there are known by their tribe, African people and Arab people, both of them, the African side and the Arab side. The government is supporting the Arab people to kill the non-Arab people, the African people. And then they take you outside and they ask you and they can beat you, because you are not Arab. In Darfur there are many tribes. My tribe is the Fur. This is the biggest tribe. With my family I don't speak Arabic, with my mum, family at home, we speak only our Fur

THE YOUNG MAN'S TALE

language. When they attack the villages the first people they target is the Fur. There are many tribes, the Massalit, Zaghawa, but the Fur are the largest and that's the one they're looking for. That's why they ask me, 'What's your tribe?' If you tell them the truth, they can beat you.

Because my family is in another camp, I have to go across the city by the north side. And when I go there, I am put in prison for six weeks in 2016. After that I decided I don't want to stay here. They are coming to attack the camp, and in the city it is difficult for me. And if I decide to go to another city, if something happens, I will be the first target, because of my tribe. I can't live in any place. So after I have been in the prison for six weeks I decide that I have to leave, to go across the border to Chad, that is the nearest border.

At the border, you can see the Chad people waiting there and the Darfur people. Lorries going to Chad, lorries going to Libya. I spend, like, one month there when I go there. And then after that a lorry into Libya.

When I cross the border, to go to Libya, that is the new life. But Libya is also so dangerous.

I go to a city called Sabha and I spend one month there but it is not an easy life there. In the morning, before 8am, 8.30am, you cannot go outside. After 2pm, to 5.30pm you cannot go outside. At night, from 10pm, you cannot go outside. And if they find you they can kidnap you and then request the money from your family. I cannot stay there. I cannot do anything. I cannot work, because you cannot trust anybody. Because if you go to work with them maybe they might kidnap you. You cannot stay there.

I decided to go but I am hearing that even if you want to go to the capital city there is the most dangerous area that is called Bani Walid. You cannot cross by Bani Walid. It's even more dangerous than Sabha. If you want to go to Tripoli, you have to go by Bani Walid. And Bani Walid is the most dangerous. They burn people there, they kill them there. You

cannot cross there. But there is not an option. I have to go. If I stay here, I cannot trust anybody. In Sabha, life is very dangerous. So I decide I have to leave.

And they catch us, they kidnap us, they put us with other people, many people in a prison.

They give you a phone, and a credit top-up, and tell you to call your family and they can pay for you. But my family can't! Because I left my family in the camp. I told them, I don't even have their phone, I don't have their sim card. Nobody can understand. Nobody can believe you. But for one month they were beating us. When they smoke the cigarette, down to the filter, they put here, and they put there, they burn you. Libyan people. For a month they were beating us and torturing us, every day for money. You need to pay, they keep saying, and if your family can't pay they can kill you. They want 7,000 Libyan dinar [£1200 approx]. And even if your family is able to pay, and they can collect you, you can be walking on the street and other people take you. Or you pay the 7,000 and still they want more, they continue to beat you, they will hurt us, they are beating you. I don't have a number for my family, I tell them. They are living in Darfur, I don't have any number to give you. And then they continue to beat me, every day at that time. That continued for one month. It was so hard.

And then at last they stopped beating us but we stayed in the prison and they took us to work each day on a farm. Picking pumpkins and olives and loading them on to a lorry and then you go to the city and unload the pumpkins and the olives. From the farm to the city and back to the farm, under a gun. Four months we were working for them, September through to January. They do not pay you or anything like that. There are usually two guards and one of them is holding the gun and you cannot run. If you want to run they can shoot you.

In the prison we were from many different countries, not

THE YOUNG MAN'S TALE

just Sudanese people. There were Nigerian people, Eritrean people, Ethiopian people. Somalian people also. They can take seven or ten of them to go to work but they cannot take all of them because any more they can escape.

In the evening, after sunset, they bring you back to the prison. We were working for them for four months. And then we decided to escape from them. But it was… some of them they have been killed at that time.

At sunset, at about 7pm, we were working in Bani Walid, and as we were going back we decided – we were ten persons at that time – we were going to jump and run. We don't know what is going to happen. We might work for them for five or six months and then they might hand you over to other people and you work for them or they demand the money from you again.

There were two guards. One of them was holding the gun. We were talking in Arabic, Sudanese people, Eritrean people, but when we are speaking they cannot know exactly what we are speaking about, because of our accents. So you could talk, bit by bit, if they agree, if they don't agree. We were agreed all of us to go. When we were back we would have to run. Then we'll see.

When we run, all of us in different directions, I don't know who of us survived, who did not survive… I don't know exactly.

Two of us, we find a Libyan person who is a little bit different from them. He took us, two of us, and we stay in his house for one day. There are some of them who are not the same. Different from them. There was another person who was very good. He took us, two persons. And we go to his house for two days, and he takes us to a market. 'It is not safe in this area,' he tells us, 'they can capture you again.'

At the market we find some of our Sudanese people there. They had been there a long time. I was explaining to them what was happening and then they took us to a house. After

a couple of months we think we have to leave, to cross to Europe. I need a safe place.

In all the time I was in Libya I did not see the government. In Bani Walid, in Ash Shwayrif, all you can see are militia, you cannot see the government.

When they have the car, the car will be black. All the windows will be black. You see the car, and the car stops, and there's someone holding a gun, you don't move. And then they can search you, mobile phone, any money, they can take. And even if you don't have anything, they can kidnap you. And they can beat you, they can torture you. They can tell you to call your family. To give them the money. And then they took us to work. We were working four months every day. And then finally we escaped from them.

I'm asking the people who have been there a long time how I can go to Europe. And they tell you there is a city near the sea called Zawiya. You find someone you can pay something to, and they will help you. We stayed there, you wait there, it's like a building but without a house inside. You can pay them something, Libyan people, and they will help you cross to Italy.

In July 2017, we left in a blow-up boat. There is a lot of water inside. We were 137 persons, thirty of us wearing life jackets. There was no room. Someone was sitting there, you could not move. It is very difficult there. Everyone was shouting, 'Let's go back! let's go to Tunisia…' No one was listening to anyone else. No one was the leader, no one was being listened to. Everybody was going to fight you. Because we were too many people we had to take turns to go outside the boat into the water. And the people with the life jackets they say, 'I can go into the water but I'm not going to give you my life jacket.' Maybe three or four times we all have to stand up, because there is too much water in the boat. The front of the boat, there is no air, two people are holding the rope. We don't even know the directions.

THE YOUNG MAN'S TALE

During that time we missed the focus. I don't know how they drifted away. Four people got lost who were taking their turn in the water.

And two days later there is a wooden boat alongside us. They cannot take us, they cannot take 137 persons. 133 persons now. They tell us, you cannot go back to Libya, or to Tunisia, or wherever. They tell us just to stay, don't go anywhere, and then they leave. We wait, we have no fuel, no nothing, we cannot go anywhere. We wait, an hour, an hour and a half.

A big ship is coming. I think maybe this is Libyans coming to kidnap us and they will take us to the prison but when they come closer, I see they are different. They give us everything. They give us life jackets for everybody. 133 people.

They take us to an island. Italian people, they put us in the camp, in Lampedusa camp. They take our fingerprints. I meet many people who had been there before me. Even if you want to go outside you cannot because Lampedusa is an island. You have to wait till the government decides to take you to Sicily or wherever. We spend one month there. We have to wait.

They take us to Sicily. Which is eight hours by big ship. They give us €7 and put us in a camp. From Sicily I decide to leave the camp and I take a bus, which takes you off the island, and then a train. The train, if you don't have a ticket they tell you to get off at the next station. I spend three days getting from Sicily to Rome. You go one station: you get off. Two stations... I have to eat on the street, you ask for food, you can find some food. If you ask for help you can find food. And then you take another train. You can go one station, three stations, if the control comes you have to get off.

In Rome I was lucky. Because when I was in my country I learned English a little bit, with the UNICEF, I can read the screen which has information in English. I find the fast train from Rome to Milan. The control, he catches me on the train. He doesn't ask anybody, he only comes to me. 'Your ticket?' I

don't have a ticket but they can't do anything. Make me get off at the next station. The next station is Milan.

I spend about two weeks in Milan but then I decide to go to France. I have to go to another city, that is the border.

If you take the train from the border the French people send you back to Italy. So we have to try, four persons, five persons, to go by the mountains. At midnight. There is no one guiding us. There are many people, thousands of people, you can find someone who has tried ten times, more than ten times, they catch him each time.

One day – I have tried the mountains seven times or eight times – but there are some people, they know the way to go.

I want to apply for asylum in France. In Paris you have to wait a long time, one month and a half, two months, and then they take you to accommodation. Before that you sleep outside. You have nowhere to stay or any money. During this time it is raining. I cannot stay outside in this cold. I decide to come here. I was thinking, during this time, one month and a half, two months, I have to try to come to the UK. If I am lucky to come.

You can take the lorry. You don't know exactly where the lorry is going. It's not every lorry from Calais that is coming directly to here. The weather is cold. The weather is very cold. One time when I was trying the lorry took us to Germany. And then when you're inside Germany, you cannot come out again. They told us you have to do the asylum here. I want to come to the UK, not learn another language.

It's a camp. One room, six persons. Some rooms they have eight beds. You have to stay there more than six months, a year. I was in Germany and claimed asylum there, I was waiting there. Unfortunately I don't get any result there. I was waiting a long time. One year in total I was in Germany. They told me because of the fingerprints in Italy, I had to go back there.

When I am waiting I learn to think nothing bad. There is no option. But then I'm thinking about my family. When I'm

worried I'm worried about my family. Maybe they're not alive. And when I'm in the detention here, I'm thinking about them. When I was in Germany I was trying to find out, trying to ask the organisation if they could get in touch. There was the Red Cross. When I came here I was trying to find out. One of my friends here, he has family in the same camp. When I was able to come to a suitable place, where there is internet, I am calling them.

In Germany, they tell me after one year you have to go back to Italy. And if I go to Italy it becomes so difficult for me to cross the border again. The police say that at 4am, they will come to take me to the airport. I say I don't want to sleep in here, I want to sleep outside. When they come in the morning at 4am they don't find me.

I decided I wanted to come to the UK. For six months I was trying every day. Every day I was trying to get on a lorry, but it was hard for me. Some people try for a year and a half, for two years. Some of them, maybe they are lucky, one week.

Some of the lorries they are going to the fuel station. Maybe you can try it during that time. Or they are going to park, and you can go inside. You think, maybe this one is going to the UK, you can try to open the lorry, you can go inside, two or three of you can go inside the lorry. You can stay inside maybe four hours till in the morning maybe this lorry is going to move. And if it's coming to the UK that's ok. But suddenly you will find yourself in another country, Belgium sometimes, Luxembourg. I have been to France and Germany many times, finally after six months I was lucky to come here, and when I came here I was put in detention again.

In the detention centre they tell me you have your fingerprints in Italy and Germany. Every day the Home Office calls me. You have to go back to Germany. You have to go back to Germany.

Any time they can take me. During the time I was in detention, they gave me the name of a solicitor and they took

my number and they gave me some papers. The solicitor will call you. I was waiting. No one was calling. And because I was worried, that the ticket to Germany was already issued, on the second day I went to them and was telling them that the solicitor didn't call me, and my time was coming, and I needed the solicitor. They gave me another appointment with another solicitor. This was the second paper. No one was calling me. This happened five times. Five different solicitors and nobody was calling me and then I was thinking maybe no one was calling me because they were not giving my number to the solicitor. And then at last one solicitor called me and I was explaining that I have only one week.

And then there was one day left, and my ticket was cancelled.

They put me in a hotel near Liverpool Street for a year. They told me to wait for my interview, my first official asylum interview with the Home Office.

It's two years now. I stay at home, I'm thinking a lot, it's stressful. I decide I have to go to a college. Maybe that will be the least stress for me. I want to study. I'm asking the solicitor what's going on. Now it's been two years and there's been no interview, no letter from the Home Office.

They give me accommodation in Essex and I go to the college. One day every week. And I decided that I did not want to enrol again in the college and I look for a college that I can go to every day. When I was in my village I couldn't go to any school. Only when I was in the camp did I study the UNICEF English course. The only higher standards course was outside the camp and if you went there the militia asked you what tribe you were.

My college is in London. In the week I stay with my friends here, in east London, because the college cannot pay my travel from Essex. I get help to buy food. £40 every week. You can buy food, but that is not enough for travel. From

London to Essex it is £11. So I stay with my friends. Tomorrow will be the last day for me. And then I have to do the exam. January, if I pass the exam, I will do Stage 2. It is the least of stress.

When I was in my own country I didn't think ahead of what I could be. Most of my time when I was in my country during the war, all that I was thinking was how to go outside. Wake up in the morning, maybe there will be an attack, maybe there will be an attack. The government every day is going to attack. Who is going to save us? No one is going to save us. They will ask me, 'What is your tribe?'

I am only thinking ahead now that I'm here, now that I go to college instead of staying at home. If I pass my Level 1, then Level 2. In January, or February, if I can do the Level 2 Functional Skills, then I have to choose. I was thinking, maybe motor vehicles mechanic. If I can.

The Human Rights Defender's Tale

as told by

JB

My name is JB. I originally come from Uganda. Our little village is made up of citizens who are proud for having witnessed how the village evolved from the horrific early days of King Mwanga's reign to the present. Our village is full of history, being especially well known as the place where King Mwanga used to kill those who rebelled against him by crucifying them on a huge tree. Historic monuments for these acts, such as the Big Tall Tree, still exist today where these people were crucified.

I come from a family of five and I am the first born. Our family was very humble and respected in our village because of the discipline we carried with us at a very young age. The drama in our family started in 2000, after the divorce of my parents when I was just thirteen years old. One day our father left our home and never came back, after having some misunderstandings with our mother. Our mother had not had much education which meant that she could not get a job for our survival. Life became exceedingly hard as things like going to school were suddenly a luxury and it was at this point that

JB

I told my mum that I was off to look for a job. She sobbed but, surprisingly, she nodded, which meant that she really wanted me to. At the age of thirteen, the best job I could find was a car washer in a town just next to Kampala Central. It was hard for me to compete with the big men, my 'fellow car washers,' as they had been there for a long time and were known by customers. The solution was to befriend them and share job duties on the same car, like washing the tyres and wheels, and I would be tipped after the payment was made. But I could not get much out of it, not enough to be able to support my family. At this point, I felt that I had disappointed my mother and my brothers and sisters, to whom I promised to do my best to put food on their plates.

After breaking my promise, I didn't feel that I deserved to be at home anymore. I found myself on the streets of Kampala near Queen Elizabeth's monument. What I saw on the streets was another kind of saga as you could not own anything of your own. Everything you had, or that was given to you by people, you had to present it to your 'Chief,' the leader of the street people, and if it looked attractive to him then it was automatically his. Be it food, money, watch, phone, the clothes you wore – all could be taken away from you if the leader of the street wanted them. I was asked to remove my fitted red T-Shirt and the pair of jeans I came in and hand them over to the Chief because he liked them. He gave me a striped dirty brown shirt and a pair of black trousers, which were huge compared to my size, and while he grinned he said, 'Now you are a beggar my friend, beggars don't look like they are going to the office.'

After six days on the street, I recall it was a Sunday, a white van with the word 'Missionaries' written on it in blue paint came by. Everyone ran towards where it stopped, a few inches from where I was sleeping. While I was staring at everyone on the street – kids, men and women squeezing and forcing themselves through to get something to eat as given by the

Missionaries – one brother dressed in a white cassock and a blue sash around his waist made his way through to bring food to this weak boy beside me. After giving the food to the boy, he asked us where we were both from and I told him the name of 'my little village.' His eyes opened wide and he said they had just got some land in that village and that, as we spoke, they were building their monastery there. 'Do you want to come with us? I will take you back home.' I replied that I didn't want to go back home because we had no help there.

He said, 'Don't worry, we will do our best to look after you and your family.' On mentioning the help to my family, before he knew it I was on the top of the van. That is how I got off the streets.

When I got to the monastery, we agreed terms. I would do what I could through my odd jobs to support my family. For whatever we wanted, like school fees, I would contribute what I could afford and the Missionaries contributed the balance for me and my brothers and sisters. Thank you to the Missionaries for saving my future. My relationship with them grew stronger through the years.

*

By 2005 I had turned 18 years of age and with the progress made in my life and in my family, the Missionaries asked me to start a youth group which could help young men just like me who were in similar situations. Given my past experience, I said yes.

That marked the birth of a youth group alongside The Missionaries, which was later registered as a Community Based Organisation/Non-Governmental Organisation (CBO/NGO). The main aim was to fight for people's human rights and to fight poverty. This group was formed with an intention of focussing mainly on youth.

By getting involved in the work of serving young people, we realised that there were many people who were more desperate, so we decided to extend our services to other areas and by the end of 2010 our group had stretched to many schools around our community. After succeeding in this, we therefore decided to establish branches in some other districts of Uganda, to be able to bring the services nearer to the people, like Masaka District, Mbarara District, Mpigi District and Mityana District.

As a pioneer and a leader of this group, I had a burning desire to think even more about the pressing needs which could be affecting society, especially where I came from. As a dedicated team we moved on with building houses for those who were badly affected by floods caused by dangerous heavy rains. We extended our relationships to more schools in various ways: through offering advice about young people's common problems; giving financial assistance in setting up small-scale businesses; helping young people seek medical services by linking them to health centres; organising outings to beaches and retreats for better quality of life; rewarding teachers in different schools to enable them to perform even better; organising parties and training for those who had finished their secondary level and were joining university.

We committed ourselves to serve mainly young people, through the activities mentioned above, and by giving advice about the most common problems young people experienced, like early pregnancies. We also held discussions about HIV and AIDS and distributed condoms. One of the common problems we heard about was young people who died silently because people would not speak about homosexuality.

To be honest, I was confused about what to do because I knew that it was dangerous to be gay and also that to help people would put my own life in danger. But I learnt how difficult it was to live in the community where people were rejected, denied jobs, discriminated against, cursed by their own

THE HUMAN RIGHTS DEFENDER'S TALE

families, jailed and worst of all killed. Many people came to me in search of safe medical care and assistance. Some were in shock after their partners were killed. They never trusted anyone and, during the time I worked with them, they kept changing names and locations for fear of others tracking them down.

As a youth leader, one of my main goals was to fight for human rights and equality. Most of all, it meant fighting against those who violated the human rights of these young men and women, but this meant a lot of sacrifices, like being ready to be judged and facing the same measures of suffering they passed through.

*

My group and I acquired some training in Kenya and on our return home we were full of enthusiasm to act in the protection of young people's human rights. We were attacked on many occasions and even injured sometimes. Many of my teammates could not cope with such dangerous risks and the threats every day of losing their lives, so they quit. Due to the rapid fall in numbers, it was like pulling the plug out of the sink because we had a big area to cover and yet now there was only a handful of us left on the team. We started facing terrible threatening letters from both the people and the authorities.

One day, it was a Wednesday, a bright sunny morning on 27, July 2011 – around 08:00am in the morning as far as I remember – my friend S came to me from home because he needed a recommendation letter from me to allow him to apply for a passport. S was gay and a couple of people knew it where I came from. On the walk to the centre with S, while we were chatting, we heard people yelling behind us that, 'Olwalero temutuwona ekimarakimala' meaning, 'Today you will not survive, enough is enough.' On looking behind, I saw it was a group of men, approximately fifteen in number, armed with big sticks and stones. Others jumped on trees to

reach out for branches which I assume they wanted to use to beat us. Immediately I shouted to S that he should run. But it was too late for him to run fast enough. As I approached him, two men, one armed with a piece of metal, hit me on the forehead. I continued running to the Teenage Centre Hospital, where I felt safe enough as I knew the workers at the hospital. On reaching the hospital the doctors said, 'JB you are bleeding too much, lie down straight and relax. What happened, accident?' I told them that I had been beaten by the angry men, but that they were not to tell anyone that I was there.

After the attack I was advised by a friend who was a retired police officer not to risk going to the police because this was a social issue which first of all had to be dealt with by the local council – and my relationship with the local council at this stage was not good.

S was declared dead on 3rd August, 2011, due to internal bleeding. He died at his home as his parents were convinced that he had no chances of living after the terrible beating. When I tried calling his number, his sister received it and warned me never to step foot in their home again as they were angry at me. Soon after that, I was given assistance from the Missionaries to leave the country and to escape to the UK.

On 25th June, 2014, I received the news via email that a mob had demolished my house and stolen everything. No one was hurt. My friends said that they were mainly looking for me. It was assumed that they thought that I was still in Uganda then.

★

When I first came to the UK, it was my intention simply to pass some time here, hoping that the pressure which had mounted at home would calm down after a while and that the time would come when it felt safe enough to go back to Uganda. It was not in my plans to seek asylum, even though I

was in fear of being persecuted. I thought things would get better with time and, when it was safe enough, I could go back to Uganda. There was also the question of not seeing my family for at least 5 years if I decided to claim asylum, which I did not want because I am very close to my family.

It is because of these reasons that it took time for me to take the big step of making the decision to apply for asylum. What eventually made the difference was the demolition of our house, especially the statement that those who attacked the house were mainly looking for me.

*

I was recognised as a refugee in 2015, here in the United Kingdom. I arrived in the UK in 2012 and I was detained on the very day I applied for asylum, without being given a clear reason why, and without being told how long I would be held for. All they told me was, 'We are taking you to a safe place where we shall work on your case very fast.' Of course, as I later found out, none of that was true. But I was yet to face something worse than the persecution I was running from back in my home country. Life in detention became the worst experience of my life.

Since I was released from detention, I have made it my business to fight for my brothers and sisters who are still stuck in detention with whatever little means I have. Not because I also passed through the same situation. Not because it's the right thing to do. Not because the whole system has failed us rather than help. Nor indeed, because it's a waste of taxpayers' money. But simply because, as an asylum seeker, detention is the worst place I have ever been in my life, and when I needed help the most. It gives me nightmares knowing that another person has to go through the same experiences every day. But I believe we could put an end to this suffering and this can only be achieved by putting an end to indefinite detention.

Put yourself in the shoes of those people fleeing their home country, seeking for refuge here in the United Kingdom, or in neighbouring countries. Once you make it here you would expect to get some sort of help or some sort of protection, right? Well in my case it was the opposite. My experience in detention was worse than I can describe.

We were held under Class B high security conditions, locked in prison cells for long hours, treated as criminals, and sometimes even worse. For an extremely vulnerable person seeking refuge from persecution in his own country, this becomes a form of torture itself.

I remember a young man in the cell opposite mine who used to cry in pain to the officers every day and night. 'Please, officer, please, take me to the hospital. Or at least give me some medication, I am dying.' But all his crying fell on deaf ears. One day, when his cellmate rushed out of the cell in panic that he was actually dying, we had to go on strike so that he could get the attention he so badly needed. When he was eventually rushed to the hospital, after he couldn't talk anymore, we were so eager to find out what had happened to him, whether he was still alive or not. But we have never heard a thing from him ever since. In shock, one of the committed men on our wing said that that sort of behaviour from the staff was not even common in the prison where he served his sentence.

Winning your case in detention in the Fast Track system was close to impossible, as the great majority of the asylum cases were rejected, and so was mine. This didn't surprise me because it seemed to me that the entire structure of the Fast Track system itself was designed to result in the refusal of asylum claims, rather than in a fair judgement on the vulnerable cases. Even though every solicitor who saw my case argued that I had a very strong case, I only managed to fight my case and be granted asylum after I was released.

Seeking medical help was a waste of time because we only had one doctor on each wing, who seemed only ever to

prescribe paracetamol. After suffering from diarrhoea two consecutive times, I went to the doctor and asked him why I was denied medication even though it was prescribed to me. This is what he had to say: 'We fear people could take an overdose. Sorry, I can't give it to you.' But then I wasn't even allowed to take it in his presence either. So, I wondered why he was there in the first place.

Eating anything was only possible with a really strong motivation to try to eat. Not because we didn't want to but because we were so depressed and traumatised by the whole situation in detention. Most of us went on hunger strike to express our grief and dissatisfaction at the way we were being treated and also to protest about being detained in the first place.

Having to witness people attempting suicide is itself a form of torture, leaving you hopeless and helpless, unable to have the mental capacity to fight your own case. It really feels as if there is a deliberate attempt to crush your mental capacity. This is only to mention a few aspects of detention.

But somebody today might ask, has the situation actually changed for the better? I guess the answer to the golden question is, No. These things still happen today in detention. And this is why we come to the call for an end to detention.

Imagine, it costs the Home Office about £96.66 per day to keep a detainee behind bars. And because of the appalling conditions in detention, and the many cases of unlawful detention, the Home Office has been challenged numerous times in the courts, by charities like Detention Action. Of course, some cases go unanswered, like those who are unlawfully deported and those who take their own lives, or suffer very serious medical conditions under this system.

I hope we can see a better tomorrow and make a change once and for all by putting an end to indefinite detention. We have to. It is a question of human rights.

The Correspondent's Tale

as told to
Scarlett Thomas

18th April 2024

To whom it may concern,

I would like once again to request help with my Home Office problem.

I expect you're very busy but I'm trapped in a vicious circle and I still need help. Even more so now, as the Home Office are trying to deport me and I don't know what to do.

Just to remind you of my story: I've been in the UK since I was nine years old. Growing up, as far I was concerned, I was British. My parents shielded me from information about the Home Office. I was not made aware of our immigration status; as far as I knew I had nothing to worry about. When I was a teenager I was doing normal teenage things, drinking in the park and whatnot, but I got stopped and searched and ended up with a street caution for cannabis. And because of that I never got my British passport. I mean, I was in year nine, so thirteen years old. Looking back now I should've done a runner or given false details, but I thought I didn't have anything to hide.

After that I couldn't even go on school trips. You know, like when kids go to France for a week? I never got to go. So you know I became like one of the naughty kids, and that's how I started to get in with the wrong crowd. I got leave to remain in my college years but I never got my passport. The rest of my family all got them, but not me. My younger brother and sister were born here, but not me. I was born in Zimbabwe. Which is where they're going to send me back.

Our exodus from Zimbabwe began back in 2004 with fleeing our house early in the morning. I remember this like it was yesterday. I was abruptly woken up. I saw my grandma (RIP) and my uncle, luggage in hand. I was so mesmerised by all the lights in the distance as we arrived at the airport. Seeing a plane grounded for the first time, instead of in the sky! I should mention that Africa, well, the part I was from, was not well lit. No street lights! So you can only imagine how fascinated I was seeing all the lights, especially after arriving to what I now call home, the UK. I don't think I'll ever feel how I felt that day; it's almost like I was in a trance. That day will stay with me forever. The airport was huge! So many planes as far as the eye could see. I saw a plane take off and land! Then I was on a PLANE! I say this with such enthusiasm, as I am aware of how blessed I am regardless of whatever hardship I may face as there are people here in the UK who've never been on a plane and people around the world who don't even know what a plane is.

I remember being in the car just looking at all the street lights, the roads, houses on top of houses, the traffic lights, shops, billboards, just in a trance, absorbing everything. Basically thinking I was dreaming. Please don't laugh, but I remember arriving at the house and the first thing I had to do was go upstairs. I used my hands to climb up the stairs which were alien to me. My education started at primary school year five. Now, I'm as British as they come. I even go on holiday to Scotland (though that's because they won't let me leave the UK, to be honest, no offence).

THE CORRESPONDENT'S TALE

The fact is, I just want to work. Here in the UK, where I live. I love work! I had a paper round back in year nine. I never had a problem getting up early. I'm so full of energy. I have 14 GCSEs. I've done religious studies, maths, English. I got a distinction in IT. Got an A in science and a B for R.E. I'm a musician and an artist. I can paint. I'm a qualified personal trainer and I've got all my lifeguard certificates. I still play football, though I'm not as good at cardio as I was. So, you know, now I'm more on the goalkeeping side.

I reflect a lot. I've now been in and out of jail so many times. I reflect. I think, *What did I do?* I try to change and better myself. I reflect. Why didn't I run away when the police found me in the park? But I thought, I haven't done anything wrong. I didn't even tell my mum about it. All I want, you see, is the chance to work and live a normal life. Am I emotionally unstable? I mean, mentally, in my head, I'm still 25 and I try not to see myself as a product of the system because I'm smart and wise but sometimes you know this situation makes me feel like life isn't worth living, especially because of what I'm putting my family through.

Imagine if you were my friend. We'd go out for coffee but you'd have to pay because I can't work. I want to work, but I can't. I'm so broke. I would love to have a wife, start a family and all these things. It takes three years of hard work just to get on the housing ladder. But I'm not allowed to work.

The truth is, I've written to you before but you never replied. I expect you're busy. Every morning you go to work. But my life is on pause and I need you to help me. I lost my 20s and now I'm trying to plan for my 30s.

I've got enough qualifications to literally go anywhere in the world and do something good, but I don't want to go back to Zimbabwe. I'm gonna get off the plane, and I'm gonna look left and look right. Up and down. Where am I going? I'm definitely gonna stand out. The way I dress. The way I speak. And I don't know the language.

It could be worse. You know I got a letter when I was in prison saying they were going to deport me to Afghanistan? They meant Africa. Turned out it was a typing error. But I was running around trying to get someone to help me. I'm going to Mental Health and saying, 'Look at this!' Like, were they really going to send me into an active war zone? But you know, I'm a comedian. I can see the funny side. I look at life as kind of happy-sad, you know? And I'm resilient.

The first time I went to prison I hadn't done anything wrong. I'd bought a little safe for my savings? I kept something in there for a friend – I didn't even know what it was. You know when you go out, like clubbing and whatnot, and you know it's been a really bad night when you wake up in a police cell? That's some hangover, right? But I thought I was just going home afterwards because I hadn't done anything wrong. And then I'm in an interview room and they show me a picture of my safe and, oh man, then I'm in prison. They sentenced me to two years! It was scary. Scary, scary, scary. Prison's not cool at all. Arriving into prison, it's like a whole different world. They strip search you and take your clothes and that's it. Freedom gone. I remember walking past cells seeing all the little lights of people's TVs and smelling all the smoke and then they put me in a room with three strangers. I tell you, I did not sleep that night. I felt so melancholy.

Imagine if we were friends. I'd come out of prison and we'd go out, maybe buy food and watch a movie. But I'd have no money. You'd have to pay for everything! It would be awkward, you know. And you'd be talking about your work, but I can't work. All I want is a work permit. Please can you tell me how to get one? That's all I need. We don't have to be friends, not really. You probably have your own friends anyways. But could you recommend a good solicitor for me? You must know one or two. And can you help me find out how to get this electronic tag removed, because I really didn't do anything to deserve it, and even if I did, I've served my time.

THE CORRESPONDENT'S TALE

My friends back then, they liked to party. Everything was party party party. And my grandma passed away, the last person I had left back in Africa. And it was my birthday times. And so we partied, you know? I tried a little bit of coke. Like one or two tickets. Have you ever done that, even just once? I was offering it to people in the bathroom of the pub and you know what, one of them must have been an undercover police officer because that was when I got arrested again. So I've got like 3.2 grams of cocaine, or maybe it was 2.3, but it wasn't a whole lot, and I've got my old phone with the numbers of the drug dealers from the past and they put all that together and gave me five years. Five years! And so now I'm in prison again with guys who'd been caught with whole boxes of cocaine and their sentences were like two years or one year and they'd ask me how much I got caught with to be in there five years. It was embarrassing, you know? Two grams! And they were all gonna be home before me! You know this stuff can really mess with you mentally. In the end, I pretended it was a quarter, just to fit in.

I have to ask you, though, have you ever been to a detention centre? They came for me when I was in prison. This was when it was all over the news, you know, get rid of foreigners and whatnot. Between prison and detention centre there's Foreign National Prison. That's where they took me. Man, there are people there from all over the world. The way people are dealt with there is not nice, though. Especially if they don't know how to speak English. It's very hard, you know? Very, very sad. So people try and help each other in the best way they can. And me being a people person, you know? I can be with all kinds of people. I just try my best to help, you know.

But to be honest with you, it was hard. I was mentally unstable. At one point I thought, Maybe I'm capable of anything. How long can I keep doing this, you know? And if they're gonna send me back to a place I don't know nothing about, like Zimbabwe, well then I'm pretty much a dead man.

Anyways, I thought I might as well do it right now. Might as well kill myself. But then I thought, *No, that's what they want me to do*. I looked around at my environment and the people and I realised that we are nothing more than our words and our stories. That's all we've got.

From Foreign National Prison I went to the detention centre. They sent me there for a month, so I had thirty days to sort out everything. And you know, I'm all out of money at this point because right about then I gave £1500 to a solicitor but all he told me was that he couldn't do anything because I'd got more than four years. That was it, I was literally due to be deported the next day. I mean, I'm panicking. I'm ringing my aunt, ringing my grandma, saying, like, 'This guy!' about the solicitor, because it turned out he wasn't even recognised by the Home Office. So, long story short, he got my money and didn't do any work. He went online and did some copy and paste stuff about human rights but that was it.

It was quite recently that I met GDWG – the Gatwick Detainees Welfare Group – and they were the ones who put me in touch with Duncan Lewis solicitors, and they got me out of the detention centre, which I was very grateful for.

So then, I got sent back to prison, in Maidstone this time, in Kent, with all the traffickers and whatnot. My release date was set for November. November comes and I get paperwork under my door saying the time I spent in the detention centre doesn't count towards my prison time, so I'm not getting released for another month! You know what they called it? Being 'unlawfully at large.' I was in a detention centre! I wasn't exactly out in the community living my best life, you know? I was locked up!

Anyways, I was getting released in a month, and I was on a license which meant I wasn't allowed to live at home. Normally if you're getting released from prison they do it in the morning, like before lunch. So I've got my little bag, got

my paperwork and whatnot. I've given away all my stuff and I'm ready to go. It goes past midday, and my friend's outside waiting to pick me up, but I'm still in prison. Then it gets to three o clock and I'm like, *What's going on?* Long story short, I get released at six in the evening. I'm meant to be at the approved premises by seven. I've got all this luggage with me because I thought I was getting deported, and now my friend isn't there so I have to ring him. I'm like, 'Where are ya, brother?' But he's gone back to Luton, after waiting all day. Now he has to come all the way from Luton back to Kent, and then from there we're meant to go to Northampton. So I get to the approved premises eventually about eleven. I'm in my room for like an hour when the police come and take me back to prison because I've been recalled for being late. So then I spent months back in prison, just for that, for being late when they didn't even give me a chance to be on time. You know, I sometimes feel like the system's against me.

In January, I got paperwork underneath my door, saying I've got a flight at Heathrow for Tuesday the 19th at six o' clock. I'm being deported, for real this time. Excuse my language but I was like, WTF? I was told I couldn't even appeal. Or, I could appeal but only from Zimbabwe. Anyways, I thought I'd at least have another month to try to sort it out, but that was because I didn't realise the date. You know, in prison, you lose track of time. I'd made myself a cup of tea in my cell, and then I saw a cleaner and I was like, 'Bro, what's the date?' and he was like, 'It's the fifteenth, man.' I gotta tell you, I panicked. I nearly dropped my cup of tea! I ran to my cell and made a phone call, and that's when I found out they'd emptied my savings account! So I'm still panicking. I've got like two or three pounds in my current account so I ring my mum and now she's panicking as well. It's Friday, everything's going to be closed over the weekend. It gets to Monday and I'm asking for emergency credit, like, 'Please can I make a phone call?'

You know when you're really upset and you're trying to calm down? It was so hard. Anyways, I get my phone call on Tuesday, speak to my solicitor, say I'm about to get deported and whatnot. But then they come and get me from prison and it's basically too late.

So then they're putting me in the restraining straps and I'm not gonna lie, it's not a nice feeling. It was really bad. I'm strapped up in a van with security escorts, from 12 o'clock until my flight at six. They give me a phone so I can talk to my mum, my solicitor, my best friend. And my best friend is like, 'Maybe Africa is nice?' And my mum is telling me everything's gonna be okay, but it's not okay because I'm literally strapped up in a van. And then finally I get through to Karris from GDWG and I mean if I hadn't got through to Karris I'd literally be in Africa right now. If I could, I'd give her the world, man. She saved my world.

So here I am. But I'm still tagged, and I still can't work. I've rung so many solicitors, but they're all booked up. I need someone to take my case. I just want to work and make a life for myself with a wife and a family, but I could get deported literally any minute. Once they've got the plane ready they can just come and get me and that's it, I'm gone.

I really need help. PLEASE, PLEASE help me as I don't know what to do anymore. I have had so many different probation officers and even when they write to the Home Office many times, they don't receive a reply.

Please let me know if you can investigate my case, as this is beyond me and I have hit rock bottom and don't know what to do. I really do need help and support, please, as I am all out of funds and hungry to work and move on with my life as it is on hold.

PLEASE, PLEASE consider helping and looking into my case. I just need to able to work, that would help a million.
Yours sincerely,
Billy.

The Listener's Tale

as told to
Shamshad Khan

A BOY UNCURLS FROM sleep
half awake

he does his chores
Unfastens each cow in turn
then dusty footed
walks it to a new patch to graze on
before walking to school
whilst walking to school
at school

he tries not to think
about his mother
far away
in the UK

He is
wondering
as he looks out of the school window
what working in the NHS
means?

With his ma and pa who were his grandparents
sister V next door
G grew up in a village in Jamaica that raised him
because his mother could not

G was the boy who could pick out the high pitched chitter
of a hummingbird
the boy who loved the iridescence of learning
wrote with white chalk on a slate board
and was angry for a while with his mum for leaving

G learnt the taste of love
fed to him on forks
by beloved neighbours and his ma and pa
doing their best

My grandmother wouldn't eat before us. Don't know how they did it. Those were happy times, I didn't see the hardship. Maybe because I was pretty young. We didn't have proper clothing. It was hot so it didn't matter. Still had stigma about who's getting school lunch. We didn't think about it despite the hunger.

The glint off a knife
marked Sheffield Steel was a sign
of the place where his mother was
He looked along its length
finding his smile distorting
His mother's message said
she would
send for him
She would save up
like for that itchy jumper she sent
She is saving up
Saving up to send for him

THE LISTENER'S TALE

Saving up
to one day send for him
To send for him and his sister
she's going to

One day
when he is aged seventeen years
nearly a man
she sent for him
she sent for them

G and his sister left ma and pa
took the flight
to reach their mother
after years of waiting
His face not yet fully chiselled
though his eyes already had a
protective film through which he saw
the sky here
in Britain
the mother country
was overcast
Foggy

When I came over I thought, this place is really dark. Everything so dull and dark. I didn't really like it. I came in winter. I remember so many chimneys. That was my experience of arriving here. It was factories. Paraffin heaters. My siblings had really bad coughs. It took a long time to get used to it: the coal deliveries; the horse drawn beer deliveries.

But those big shire horses, they were beautiful, huge you know. I've lived here since 1975, with my mother and her husband, that's my stepdad, and my sister and my siblings who were born here. I did a couple of years in Hackney college.

My mum used to throw a pardner: a group of people put

in a hand of money literally every week and saved a certain amount. It's like a bank based on trust. My mum was the banker. You go round, at a certain point one person gets the money, the draw. Then start again. Someone else's turn to get the payout. That's how my mum saved the fare for me. That's how a lot of people got mortgages.

There used to be Mr Singh. You could purchase a blanket and he would collect weekly fees. He had this van, samples of things. Music and a pub on every corner. Mothers used to leave prams outside and they'd be inside. Milk left on the doorstep. Milk and bread.

I left home around 1979. I was the oldest one. I got a flat in Hackney. When I got my own place, it was really exciting getting a portable gas fire, to get warm. Got the council to remove the coal bunker, still have the fireplace active.

I was an apprentice in the clothing trade. There was lots of work. Could literally walk from one job to the next. I worked full time in the garment trade for many years. Some of it, no record of it. No tax and NI paid by the companies. No belt or braces. But I've got evidence with Finch Palms and Ford Motor Company.

The problem was my birth certificate. We sent for one from Jamaica. My mum paid a lot of money. They sent a copy. It doesn't even look authentic. In the end I kept the copy. I used to have lots of problems with it. Tried to replace my Jamaican passport. I should have pushed it, but I didn't. I wasn't ready to do any travelling, I thought I could save and get a property.

I remember when I was working at Ford's. They had huge properties in Notting Hill Gate. Selling properties for £1. High ceilings, windows, huge, tall windows. I was actually interested in buying one, I had money in the bank. What I did? I went and bought a BMW.

I used to give my mum money to look after it. And then I'd take it and use it on fancy things. I didn't think of long-

term security. I used to party a lot and have fun. I didn't smoke or drink. Financial literacy, they're not teaching it in school even now. I have seven boys and one girl, even now they are not teaching it in schools. My first pension policy; Pears insurance Company. I let it lapse after a few years. Oh my goodness.

I started a few schemes and let it lapse, not seeing the big picture. I didn't have anyone to give me direction. You have this money to make sense of. It wasn't serious thinking, I wasn't financially smart, clever. I left it way too late to get my property. I only became aware when literally I was in my 40's, became smart. This chap, a financial adviser I met, that's when I became aware.

I got right on track
Literally
working on London Transport
You could say I'm part of the city
I've got it in my bones
Feel a train coming way before you hear it
shunting routes
throwing the point
securing the point
London Transport running smooth
I worked
literally on every line on the underground
Every inch of every track
literally
Except the new bits
on the Northern line to Battersea
and the Elizabeth line that's it
The rest of it
I've literally
I've walked it
Know it like the skin on the back of my hand

Banksman; female workers do that now, platform work, track engineers, protection master, train master, site person charge. You can't have people and machines in the same area or someone could get killed. Especially the engineer train may be running with its own current. You have to get the current discharged, specially in depot. Shunting is where the train master ensures the track is thrown to the right route. And when you throw the point you have to secure the point, so it doesn't move back and derail. I would have liked to have been an engineer train driver. I know all the routes. You run all the tracks.

G explains
that he's had
two stints in prison,
the first one for seven years.

He was recalled
just before Covid hit:

That was a crazy time. I was inside for a year that time. Locked up for nearly 24 hours a day; let out for maybe an hour, or half an hour because they didn't have the staff. In prison, so many people in there can't read and write. That should be part of your sentence plan. Not the stupid programme plans that don't rehabilitate you. It's a really poor system.

I had the law firm looking at my case
trying to get me bail from prison
The parole board said
they were writing to release me
I was going to be released

One hand on the handle
of the prison door

the other hand
receiving a £75 discharge grant
Before I could even imagine
what I'd spend it on
they took it back

they like to surprise you
the Home Office
They said they want to detain me
for imminent deportation.

Since July 2020 the Home Office are saying: we are about to deport him. It went to tribunal and the Home Office said going to deport in fourteen days. They said he's not complying. Not engaging with the process. The judge looked at my file and said: he's given all that was asked for. What is he not doing? In the end the judge gave 28 days to reach a decision. They came back with a reason why. And now that's why I'm in this situation. I was in detention for months.

I got help from BID (Bail for Immigration Detainees). They help anyone in detention. But once you are out of detention they close the case. They referred me to a lawyer to see if they can take my case. I've been trying since I've been out. I've tried at least six law firms. They say they will look at it. You can actually get legal aid, but they say sorry, we are over capacity. I guess my case is maybe more… difficult.

I'm not talking about undocumented people. I've been living and working here and the Home Office knows you are not unknown. There is no reason to deport you. I'm not a prolific criminal. I've been in the country, I've proven that. They say you might abscond.

G has to report to the Home Office.
He is tagged.

When you go to sign at the Home Office
it's a marketplace

Sign
and out
Sign and
out
they don't
have time
I said I'm having issues
I lost my phone
I lost my home
it's not sorted
I get to know
how it feels
to feel
alone

They gave me an email address. Probation officer said it's a dead email. No reply. Now my probation officer, he's got through to my Home Office caseworker. He knows the caseworker has received it. Hopefully this week it will get sorted. Because I'm on Home Office bail, they are handling my case now. They have revoked the indefinite leave to remain. So no recourse to public funds. They've placed restrictions: not allowed to work and can't claim benefits.

I was on the phone holding on for
four hours
on one call
holding on
holding on
I let go
hung up
Migrant Help

THE LISTENER'S TALE

No response
They're overwhelmed
Over
whelmed whelmed
Just like me

I'm still wondering about my pension. I've paid in. I worked for 40 plus years. Fifteen years' national insurance. Some of the clothing firms used to pay it and Ford. But there's those years in between I've got to account for.

To take away everything?
Your right to work?
So you can't support yourself
I think it's inhumane
It's ridiculous
Even if you have your own accommodation
with no right to work
you can't keep that place
It's impossible
I can't even claim
It's ridiculous
imposter syndrome
kicks off
Really hard really
Tough
Just setting you up to fail
Tripping you up to fall
on your face

If they had released me like they did before, I'd be in full-time work by now. I seen ex-colleagues; they said, why not come back. I couldn't say. I felt ashamed to say. Exhausted, not just physical, mental. Don't seem to be getting anywhere.

No reply from the Home Office case worker
not by phone or email
Almost street homeless:
a doorless space
with no open doors
The main reason I'm in this position is
I've been released from detention
Home Office detention centres
are worse than prison
by a million

In Brook House, there's people smoking weed. Smoking I mean in the building, cigarettes, weed. I see people with mobile phones. They take your phone away. Next week, another. People trying to rent their phone. You don't get sanctions like in prison. They say it's not a prison, but it is. In prison there are drugs, but in the detention centre lots of drugs. It's easier to get them in. Contraband. Inexperienced staff.

Whilst I was there
chap opposite
I used to talk to him
A quiet chap
They were going to send him home
Just topped himself

I was one of the cleaners
and his cellmate was one of the cleaners too
We were out for just half an hour
Came back
and he was hanging

First time I've seen…
They were trying to revive him for ages
I said no way

THE LISTENER'S TALE

When the ambulance came
they put him on a stretcher
No way of…
Must have been hanging for minutes

They spoke to the cellmate
In prison the listeners would go
Listeners like me

I've never witnessed someone… do something like that. After the event, in prison, they would speak to anyone affected. But in detention, not that kind of support. His cellmate, they moved him. No support and none for me. I guess I was aware as a listener, so, I could cope. The officers needed more support than I did. Lots of inexperienced staff. Kids. Literally.

It's not ideal at all.

Not sure it's a superpower
but I've learned to listen
like I'm panning for gold
with my ears

I think I understand people more
and I judge less
Less Judgemental
Because in prison
I used to be a listener
on 24-hour call for inmates
if they weren't coping

Listening helps
helps you turn your prison garments
inside out to see
if there's a silver lining

Rather than speak to prison officers, we're more likely to share with another inmate. We got really good training. The Samaritans came in every Friday to brief us. If we need support; confidentiality kept. I was in the prison council representing the wing to solve problems.

When things got tough inside. I listened to people who felt they had reached the end. I used to wonder – how come, come on there's always hope. But now I see people sleeping in the cold and rain. On the pavement and see them in a different light. I used to give them change. Think how do you reach that stage? But now I know we can't see when someone is in need. I can feel empathy with those inside who wanted to end it. Because you can't see a future. Can't, can't see yourself sleeping on a bench.

G's son didn't reply to G's messages
whilst G was inside
Didn't see the bigger picture
There is no home when G gets out
but he is thankful
that for now
he's been put up in a hotel
by GDWG
He doesn't have any idea
what's going to happen tomorrow

I was thinking of volunteering in the food banks. I like to volunteer. I did it for six years in the Territorial army, I like the activity, meeting groups of people.

Family has kept me going. Just handouts from relatives and they can't really afford it, they are having it tough themselves. Sometimes from charity, from foodbanks. I see this as my home. I put down roots. My grandparents died. People I know in Jamaica, uncles and aunts: dead, or living in Canada. My age

group they are all in Canada, America or here. I've got cousins there, I don't really know them. They've emigrated to different places. I liked the countryside, but I love London. I feel like I've lived here all my life.

Since I've been out, I've not used the gym. Used to help a lot when I used to go. I've been too busy trying to find somewhere to live. The present issues I'm facing: no recourse to public funds. Not allowed to work. That heart attack back in 2003 is rearing its anxious head.

G is type 1 Diabetic
Insulin-dependent
arthritic joints start
seizing in the cold
despite a life of workouts
and a healthy stocky build

Regrets?
One or two
Wheel spins
Mud sticks
the BMW I blew my money on
that's a hard one
Can't let yourself be derailed
Got to shunt the track and fix it
The house I bought
at the wrong time
Financial crash
Should haves
Who doesn't have them?
A mortgage that could have been
paid off by now
If only…
If you have children
you want to give them a step up the ladder

G smiles confessionally
What I would have said to my younger self is:
'You should have listened to your mum.'

I consume books
History, kings and queens
royalty, British slavery, lots of civil rights
If G was in the driver seat
he'd be an engineer train driver
He'd get into writing
He'd throw a pardner
with an open hand

What our systems give
and what they take
If only England the mother country
was more like a Jamaican cow
offering unconditional suckling
Oh our sacred cow
the NHS
readied for the slaughter

Little did we know
what we were clattering for on our doorsteps
For whom we were clapping
For G's mum
For little G who gave her up
G our deepest
appreciation
Now we get it
Now we see

The Stranger's Tale

as told by
Raga Gibreel

IT WAS LATE SPRING, my first in the UK. I got off the Number 466 bus at East Croydon Station to get a prepaid phone card after a sleepless night. The young man from Afghanistan recommended 'Smile', a new card. They sell these cards near the station entrance. Then I made my way to the House of Fraser and took the escalator to the third floor. I needed to call home and hoped to find a bit of privacy there.

I had been feeling on edge for days, for no particular reason I could think of which was strange, because things seemed to be going in the right direction! I had already found myself a job; I was in awe of everything around me, even the red London buses. I said to myself, I've got an oyster card in my hand and I'm free to go wherever I like. I felt safe hanging around the shopping centre or taking refuge in the library. People seemed to be friendly, but despite all this, I felt the weight of the world on my shoulders and my chest was tight. So, I decided to call home. I thought that if I heard their voices, I would feel reassured and the feelings of doom would disappear. I was thousands of miles away from home yet, my body knew something was not right.

The shopping centre was milling with people and things, summer brings everybody out.

I sat in a corner and took out my £10 prepaid card. I did not really know if I could afford it, what with my £100 per week rent and Oyster card and university fees coming up soon.

I found a penny to scratch the PIN number. As soon as I dialled, I heard my mother's usual enthusiastic, 'Hello, there is a whole gang here waiting to greet you.' She passed the phone round… I could hear my sisters' voices in the background.

Suddenly, I heard a strange noise. My call was interrupted by a burst of military music blasting out. That was it, that was the end of my call. It left me in a total state. I couldn't figure out what was happening. I howled and cursed out loud. This was only one month after a failed yet bloody coup d'etat. I felt enraged and fearful for my family. Was the violence starting all over again?

Someone said over and over again, 'Good lord! Don't curse / *aistaghfar allah*.'

Others were looking in my direction. Some ladies came to ask if I was alright.

I said yes, but felt utterly ashamed.

At this very moment, a person came and stood in front of me. He asked if he could sit next to me. He was wearing blue jeans, a waterproof jacket and carried an old rucksack over his shoulder. He looked like someone who had been on a long journey.

He kept apologising for interrupting my thoughts and only stopped when I said, 'No offence taken.' I wished him a good day and left as quickly as I could.

To my surprise, I bumped into him the very next day. I was waiting for a bus by the post office.

'Hey,' he said, 'I meant to ask you yesterday, are you from Sudan? I think I heard you speaking in Arabic.' I just nodded and gave him a wave. Luckily, the bus came at that precise moment.

THE STRANGER'S TALE

As I was boarding the bus, he shouted, 'You can find me at the centre any day of the week.'

Three days later he appeared at the bus stop again, just as I got off. We walked along to the centre where I was intending to have my lunch.

He introduced himself. 'My name's Mustapha, my father is a well-known Imam in Eastern Sudan.'

That really irritated me. Was he bragging?

So, I replied, 'My grandma is well known too. Her brewery produced top notch liquor. People only went elsewhere once she had completely sold out.' With that, Mustapha burst out into uncontrollable laughter. I saw the funny side too. That's how we became friends.

Jeanette, the cleaner, said, 'I have never seen him laughing this hard, what did you tell him?'

A security officer said, 'Mustapha has got a new girlfriend!'

Wiping away his tears Mustapha replied, 'She's my sister'.

From then on, we became unofficial next of kin for each other until I left Croydon.

Mustapha told me his story. He left Sudan ten years ago to study medicine in Syria on a scholarship. He completed his three years, but then the money stopped. Things had not gone to plan. So, he travelled to Europe by crossing the Mediterranean Sea, a well-known route from Syria for a better life.

He arrived in the UK six years ago and had to report weekly at Lunar House. He was physically healthy, but homeless, with no money, no possessions, no right to work or access to public funding. I had no idea that this could be the case, that he couldn't work. He couldn't be supported by any homeless organisations. In winter some churches open their doors and offer hot meals. He had to be careful, as the streets are not safe.

Mustapha was a proud man. He kept himself immaculate despite his circumstances. He kept all his possessions and papers neatly organised in his rucksack.

He would never accept any money, not even for a cup of tea. He was extremely resourceful. He found ways of accessing food and drinks by spotting offers by big companies like McDonalds. He taught me about 'Buy one & get one free.'

He also taught me something about dignity. He would bring me the Metro paper, particularly when there were stories about Sudan. He would feel it was his lucky day when he chanced upon a Guardian left behind outside on a café table. It was a story of survival.

Some days he looked ashen, as if he was fasting at Ramadan. Some days he seemed to be in a world of his own. We did not speak much about our families, but, one day, he told me that the last time he spoke with his mother was seven years ago. He said the most painful thing was that his fiancée was waiting for his return.

He had a cousin in London. He reluctantly called him. The cousin came at once and offered him accommodation in the family apartment. But Mustapha, being a proud man, could not accept it.

I learnt something new about how living in exile puts a great strain upon family relationships. I realised things are different here. He was afraid of putting pressure on his cousin. These fears would never happen back home where families always rely on each other for support, as there is no welfare system.

One day during this summer something unusual happened. Mustapha was sitting in his usual spot at the centre when two police officers came up to him. I saw him handing over some papers.

I couldn't work out what was going on. Everyone was looking, passers-by, the cleaners, the security guards, workers at the nearby café. Everyone was silent and tense.

I wondered whether there was something I didn't know about Mustapha. Why did the police want to speak with him? Some of them were on their radios. Then, I saw them handing

him back his papers and announcing to the onlookers that there were no concerns. Apparently, they were just making sure he was okay, they said.

My first shocking experience of 'Stop and Search.'

'These people have no conscience,' Jeanette muttered.

Jeanette brought him some tea. 'A cup of tea goes a long way,' she winked.

There were sighs of relief all round.

Mustapha and I never discussed the incident again.

We saw each other from time to time but, after I left Croydon, I lost contact and never saw him again. But he is there in my memory and I am left wondering what became of him.

The Footballer's Tale

as told to
Guy Gunaratne

IT HAD BEEN A month or two since we last spoke. You said you could not concentrate at school, had told your teacher to *please allow me to go home*. When I miss your call, you message me on WhatsApp later, writing, *I am on the road going home, please call me later.* When we do speak, you apologise and tell me you were feeling very down, had felt very unwell these last weeks. I say no need. There has always been a warmth about you, an openness which makes me lean in to listen, want to be there for you. I felt this same openness when we first met, that you are a kind man. *I am a positive person, Guy,* you tell me often. *You can see I am very sociable, try to smile and keep my face, even when I am struggling – I smile.*

You did not disclose your sexuality when you arrived in Britain. At Heathrow Airport, you went straight to the desk to claim your asylum. You filled out their forms. You were then told your claim would be processed for evaluation. *But I did not declare exactly why I had to leave Nigeria. I am bisexual. I felt my life was in danger. But I did not disclose this at the beginning... I thought I would have time... time to explain...*

You come back to this moment – you, at the asylum desk at Heathrow – many times when we talk. I realise that you must have gone over this story, and have repeated it many times since

– to solicitors, lawyers, judges. At the time of our meeting, it had taken over four years for your case to be 'processed' through the UK immigration system. It is still not over. I hear your frustration now, your sadness at this. At having to tell it again, to me. *It is as if who I am, everything, is swept under the rug.* As I watch you say this, you shake your head and offer a weak, half-smile, wondering what a story like yours is worth to anyone who hears it. I try and tell you that your story matters, even here.

In Lagos, you told me once, you had been a promising footballer. *I had big dreams and was always active.* You played every week for a local team, progressed rapidly, and were scouted often from an early age. *Many times some people would approach me and say they wanted to represent me, to send my details to big teams, market me to Europe.* You say that if you had been born in another part of the world, in London, in Paris, Berlin, you would have had the opportunity to play for one of the *big European clubs.* I watch your eyes widen as you tell me this. You speak about this time in your life, a youth filled with possibility, and promise. I can hear nothing that is tinged with regret or sadness. *Now I know how things are difficult for youngsters. There are many times you can be taken advantage. I was able to help boys in Nigeria, give advice, and they trusted me because I know how tough it is to make your dreams come true.*

You show photos on your phone. Football kit, black with laced boots on. You are running, attempting to win a ball on the pitch in Nigeria. You look younger in that picture. You are fit and focused on winning. I mention famous Nigerian footballers of the past, how I used to admire them; Jay-Jay Okocha, I say. *Don't forget Nwankwo Kanu,* you say, *who played for Arsenal.* You take the phone back and swipe to show me another picture of a young girl on piggyback. She is adorable and is holding tightly, arms around your neck. *I adopted a daughter in Lagos. Someone I know, a friend, who was in need. For her little girl, I am the only father figure.* You are smiling in the photo, so is she. *My own dreams are more focused now. I wanted to come here and help her. But*

even now, the officials do not allow me to work. I am fit and healthy and can do anything they want. But they do not let me work, Guy!

You tell me that after you first claimed asylum, you were sent to Cardiff for accommodation. You thought it would be only for *3 or 4 days processing*. But you did not hear anything from anyone for the longest time. You were in a shared room with other people. *Just waiting, thinking, suffering.* Like everyone else. You had sent the Home Office more details and had by now disclosed your sexuality, and the reasons you needed to claim asylum. You thought it was a only matter of time until you would be allowed to contribute to society, *to live my life here,* you said. So you kept on waiting, until, one day, *I was sleeping in my bed, and then – Boom! Boom! Boom! – three or four men, hefty men, came to take me away. They secured me and put me in a van. A white van. They tell me I am here illegally. They did not listen after I told them I was waiting to hear from the authorities… they didn't want to hear me!*

You were driven to an immigration removal centre. You were made to put on the same clothes as everybody else being held, *white shirt, deep blue trousers, light shoes.* You were sent into a single room with another detainee. *They put messages under the door. I did not know how long they would keep me, they told me nothing.*

You say this period of your life was very difficult, you felt confused, felt desperate. *We were restricted from lots of things, from freedom.* You were also surrounded by people who seemed close to breaking. *There was a woman,* you said, getting quieter as you spoke, she *was from Zimbabwe, I think. It was very difficult for her. She became mentally sick in that place. Many people inside are sick having no hope. I found out she had committed suicide. I was very sad after that. I did not know if I would go the same way as her. I needed help.*

When you and I first meet we are joined by someone from the Gatwick Detainees Welfare Group, an organisation advocating fair treatment for those detained under immigration powers. *GDWG has affected my life so positively,* you tell me, *giving me hope and contributing to my wellness and mental health. Through the ordeal of detention, just one phone call from Karris,*

giving me a listening ear, was transformative. When GDWG first got in touch with you, you had still been detained. You told them your story. You told them as far as you understood, your case was being processed, and had been waiting to hear an outcome. The person from GDWG said that your story sounded typical. In many cases, refugees who are picked up and detained in similar circumstances are allowed to leave shortly afterwards. Meaning that their detention actually holds no purpose, is completely arbitrary, and results only in deeply felt trauma and devastates mental health.

GDWG decide to help you. As you witness others around you get deported, it feels like a miracle when you are not. You are heard at last. You are taken back to Cardiff. You are given a solicitor who shores up your claim, your story. And as it is issued with a new number, sent to be processed with amendments, you are asked to wait it out again. In Cardiff. But in the meantime, you are denied the right to work. You are kept in a house with other residents, also refugees, who are waiting to hear if they are granted the right to remain. I hear the relief in your voice as you describe the years after your detainment. But I also realise that, according to your timeline, you are recounting the years just before COVID. Before the world shuttered closed. *Everything stopped when it was COVID. It is now four years I have been waiting. I have told my story for many people. So many times.*

It is the first time I truly hear the traces of your desperation and regret. It occurs to me that you must have turned it over many times in your mind. What more you could have done? Maybe if you disclosed your bisexuality as soon as you arrived, you wonder, maybe things would have been easier. You were hesitant, you said, because it is a private matter. *Now I have to say it again, and again, I have to clarify and explain… I am bisexual. But they always ask me why I did not tell them before. As if it is only now I have come out! I told them within three weeks of my arrival about all these things. Did they forget? I sent them the letter! But now, again, and again, I have to explain.*

THE FOOTBALLER'S TALE

I sense that you are drained. Telling me this tires you profoundly. It is as if the repetition you are asked to perform *again and again* has become an act of surrendering your privacy, your dignity, over and over, for others to judge and decide. Your story has become not just your lifeline, not just a justification, but also the method by which an unfair immigration system has kept you in a holding pattern, fixed to your past, your own words, constantly questioned.

You tell me how eager you are to get on with your life. You want to offer more than what you are permitted to give. *Every day, I work with different volunteer groups, and charity organisations, but I cannot work more than that. I am not allowed legally.* You tell me that there are stories of others who have taken jobs, *cash-in-hand* in order to survive. *They say come, I can give you a job, just take it, make things easier for you – but I want to do things the right way, the legal way. I want to do things correctly, Guy, but it is like I am punished for going down this path...*

It is the post-detention period of your life that has taken your spirit from you. The endless wait, the sense of invisibility, false hope, and the re-arranging of hearings and appeals to decide your future. You tell me that you are now an *old man* in the house you live in. Meaning that you have been there the longest. *There are others who I live with, who have the same status, who, within six months, are out. I am the one that stays and watches by. My case is going in circles and I stay put. I don't know how long I can take it...*

When I missed your call, you message me later telling me on WhatsApp that you left your class early. You could not concentrate.

When we do speak, it is on video. You are sitting in a white T-shirt, and you are smiling. It is the kind of smile that I have learned to recognise as a survivor's smile. An agreeable expression you've made for me, not a reflection of how you feel inside. Every month, you say, you are required to go and sign a paper to prove your presence. *But they tell me, Guy, if I miss even*

one date, don't show face, make one mistake, I will be deported. The fear sounds out of your voice as you say this. I can see you are lying down now, rubbing your eyes and head. Your head aches, you say, and you are feeling unwell. *I cannot be active anymore, my body it aches, I don't even want to move. I cannot concentrate. It is really bad these days – I have never been like this before in my life.*

Whenever we speak, we talk about our daughters. Your daughter is ten years old. Mine is four. You tell me that *you must understand, as a father, how difficult it is.* You tell me you often become upset whenever you speak to your daughter. Her mother does not have enough to provide for her. *Not enough even for shoes or food.* And you tell me, *as a man, I want to provide for her – but I am not given the opportunity to do this.* You become very quiet then. It's now as if you are speaking to your daughter through the screen. *I am not perfect,* you say, *but it's like no-one wants to hear me talk. Even when I do talk they do not want to hear what I am saying.* You shake your head and look up at me.

Recently, you say, when you write to update me, *I completed a Youth Mental Health First Aider course, for which I obtained a certificate. I am currently a football coach at Oasis Cardiff, supporting youth development. The course has helped shape my life, my mental health, my way of reasoning, how to relate and communicate with people and children in my field, to know how to deal with persons with mental health issues. I am looking forward to university to obtain a degree in football coaching and performances.*

You are smiling again now, but sadly, knowing you will likely tell this story again, to yet more people before you are given the chance to live freely. *I am still waiting for the tribunal and I have not heard from my solicitor since last year. I still sign monthly at the Home Office reporting centre. I have got no current identity card, which has been a very challenging issue.*

People who are in my status, you say at last, *the truth is just swept under the rug. I will have another tribunal, another appeal, and will explain to them what I explained last time. I will keep trying. But, honestly, I really don't know for how long.*

The Campaigner's Tale

as told by
Seth Kaitey

I GUESS THE TITLE of this tale could be 'Light after the Doom'. I joined Refugee Tales in 2015, when we first walked in solidarity with people who are in detention. I myself was in detention for seventeen months. After that I was released. But I have lived under this Home Office regime for twelve years. Twelve years I was waiting for a decision.

I was liable for deportation, that is what they said. That's why they threw me into detention. I spent seventeen months in detention and after that they brought me out and I was under house arrest for twelve years. All that time I was supposed to be deported, so I was waiting for them to deport me. But actually, because my country didn't recognise me, there was no way I could be deported.

At the end of my first conversation, or argument, with the Home Office, I knew that these people had lost my documents, by which I mean my passport. And because of that I was under this regime for twelve years. I was supposed to be deported but also not deported. For twelve years my life went on like this. I was really, really under pressure.

What you also have to know is, my family was separated.

I didn't know where they were; I was asking people for twelve years. Before I came here, you see, I was married with children. You might ask me, then, why I came. In my country, I campaigned against FGM and because of that I was attacked. You know what FGM is, Female Genital Mutilation. I tried to stop that awful practice and for that reason I was attacked.

I have always tried to help people. Many years ago, during the civil war in Sierra Leone, I worked in refugee camps to help people who fled Sierra Leone and crossed the border into my country. As much as possible, I have continued to do that kind of work, the work that I want to do. Through these twelve years, I have worked as a volunteer with a lot of organisations. This is my passion, to help anyone that I can help.

So now I want to thank my fellow refugees and all those who have helped me to achieve this great thing in my life. Because the good news is that after all this struggling, after the Home Office and their hostile environment, after all the mistreatment they have given me and all asylum seekers, the good news I have today, for you and myself, is I have been granted leave to remain.

And so I have to come back to GDWG, the people who supported me throughout these twelve years. Without them I would not have survived. I want to say that they supported me by all means. Was it conversation? Was it advice? It was everything.

There was a light, you see. The light was Gatwick Detainees Welfare Group. They supported me, sponsored me, enabled me to go to college. I qualified as a mental health advocate because of their support. I am here today, having finally secured my status, because of their support.

People have asked me, how did I feel when I received this news? I felt like a great load was taken off my shoulder.

Sometimes to smile becomes very difficult. Sometimes if I smiled, it was a false smile. But deep in my heart I was not afraid. And today, I am free. There was a light after the doom.

Afterword

On the Politics of Detention, July 2024
SINCE REFUGEE TALES STARTED planning for its first walk in 2014, the project has been of the view that the UK's policy of arbitrary, indefinite immigration detention is a central issue in contemporary politics. There is much about the practice that can make it seem otherwise: the fact that detention centres (immigration removal centres, so called) are frequently at the margins of the country, at airports, on cliffs, on islands offshore; the fact that people detained are themselves silenced, their stories and therefore their experiences practically excluded from the public record. Detention has been a political embarrassment, perhaps, hence the fact that at some level it has remained hidden; even now, it is not widely enough acknowledged that the UK is the only country in Western Europe that detains people indefinitely under immigration rules. For many policymakers, however, it has been possible to look at the issue and then look away, to worry, perhaps, that the UK treats people in this way but then to stop short of giving the question due consideration. By definition, it could seem, arbitrary, indefinite immigration detention is a peripheral issue.

But it's not, never has been, and as we prepare *Refugee Tales V* for publication the centrality of detention to British politics could hardly be more clear. On the Sunday before the local elections on 2 May, the Prime Minister announced that there would be a 'round up' – this is the language – of people who had come to the UK to seek asylum and whose cases were

deemed inadmissible because of the routes they had taken. Under the terms of the Illegal Migration Act – though not, as must repeatedly be pointed out, under the terms of the 1951 Refugee Convention – people who have recently arrived in the UK by any means other than a resettlement process are now considered to be in the country illegally and are therefore liable to be deported to a third-party state. It had been clear, because the legislation was in place, that the process of detaining to remove would begin before long. Still, it was shocking – profoundly disturbing, in fact – when on the eve of the local elections the Prime Minister announced that the policy was to be activated and that, on a mass basis, people were to be arbitrarily detained. Immigration Enforcement buses were to be sent to locations where people seeking asylum were being housed and then they would be taken to detention centres, or detention spaces such as the Bibby Stockholm barge. And from those spaces of detention they would be put on a plane and sent to a country with which they had no connection. The Prime Minister's announcement appeared to usher in a new reality in the UK: the rounding up for arbitrary detention of people seeking asylum, in the interests, as commentators understood it, of electoral advantage.

Responses to the announcement were immediate and intense. Organisations working with people who thought they might be vulnerable to the process reported extreme anxiety; individuals were uncertain whether to report as required at Home Office reporting centres, where they might be detained, or to risk not reporting and going underground. At the time of writing people detained in Brook House are on hunger strike, threatened as they are with imminent removal to Rwanda. In Peckham, following the example of residents of Margate, friends and neighbours of people threatened with deportation surrounded the bus by which they were to be transported and refused to allow it to move. The Bishop of Dover thanked those who had blocked asylum

coaches for the compassion they had shown to the most vulnerable. It might now be 'legal', because the government has made it so, to detain people arbitrarily pending deportation to a third country, but it is not just, it is not in accordance with human rights. Detention, which at various points has seemed liked a marginal issue, is now being contested on the streets. At the moment of writing, it is understood to be central to contemporary politics.

We need to register what that centrality means. To detain people arbitrarily and indefinitely under immigration powers, in the dehumanising conditions detailed by the recent Public Inquiry into abuses at Brook House, is to define how the State relates to people from elsewhere, where that elsewhere equates principally to the global south. It is also to endorse a practice that, as history should surely have taught us by now, becomes self-fulfilling. To detain people arbitrarily is to so manifestly breach their human rights that it becomes necessary to deny their humanity, therefore giving the state permission for further forms of abuse. It has been awful to see leading UK politicians manipulate arbitrary detention for electoral advantage, but at the same time not surprising because the logic is all too clear. As Volume V of Refugee Tales goes to press, we have to understand how we have arrived at this place, and we have to listen to the people who, through their experience, can show us a different direction.

From the Hostile Environment to the Expulsive Environment
Since Refugee Tales first started out in 2015, the landscape through which it walks has altered. In saying this, the meaning is metaphorical. The walks largely take place in southern England, since that is where the organisation is based, and so the ground itself has remained quite largely unchanged. What I mean by saying that the landscape through which the project walks has altered is that the environment itself has carried an intensifying political charge. What is primarily at stake in the

walk, in fact, and in the politics to which it is opposed, are the terms in which the environment itself is imagined, the way the landscape itself is framed.

That political charge was first explicitly applied to the landscape in 2012, when the then Home Secretary announced the intention to 'create a really hostile environment for illegal migration'. It is a phrase which has attracted a great deal of commentary in the past decade, not least because, unlike some political pronouncements, it was made true. It has rightly been observed that the word 'illegal' is used erroneously. Under international law, as initially framed by the 1951 Convention, it is entirely legal to seek asylum in another country. That is precisely what refugee law is about.

In considering the phrase, we should note the use of the verb 'create', since what it confirms is that the political realities with which we are repeatedly presented are in fact acts of thought. It is such acts of thought – deliberate, meticulous acts of political thinking – that we need to keep underlining. It is worth thinking for a moment also, however, about the term 'hostile environment' itself. It is a phrase which can sound somewhat vague, indicating a kind of broadly antagonistic space. To speak of a hostile environment is to picture a territory that is generally unwelcoming. What we need to keep constantly in mind, however, is the degree to which the environment itself has been constructed.

To give just a brief image of this through a few details of immigration legislation, the person seeking asylum in the UK continues to be prohibited from working. That prohibition is itself environmental in that it denies any kind of productive relation to lived space, where such a prohibition can continue for years, not uncommonly over a decade. At the same time, it is important to note that a person *is* allowed to work in a detention centre, for the deeply abusive payment of £1/hour. Detention centres, it should be emphasised, are privately run and profits are increased by such abusive rates of pay. We might

AFTERWORD

also note in passing that Graham King, the CEO of Clearsprings, the company that was given the contract to 'house' people seeking asylum, has just entered the UK rich list, his company making £26m from the contract, clear evidence, if it was needed, that the hostile environment is also an extractive environment.

In the absence of work while seeking asylum, a person might receive a statutory payment. That payment is just over £35 per week, approximately £5 a day, on which a person might be required to survive for months and years. Crucially, when the payment was introduced, it was made not as cash but in the form of a voucher, where the voucher could only be spent at certain shops and on certain items and one item on which it could not be spent was public transport. This is environmental. Unable to use public transport, the person seeking asylum would have to walk everywhere, where the movement through space has been constructed as a negative act. One place to which a person seeking asylum would have to walk is the Home Office reporting centre. It is when people report, or sign, that they are most likely to be detained or re-detained, and so the regular journey to the reporting centre is framed by acute anxiety.

When detained, people are frequently moved from one centre to another, quite commonly at night. In the UK prison system, as Lucy Williams has pointed out, it is not legal to move people at night, in recognition of the distress it causes. People held in detention are woken at three in the morning to be told they are being moved, but often not where they are being moved to. Likewise, a person who is provided with accommodation under the National Asylum Support Scheme (NASS) – an increasingly rare occurrence – is frequently moved at short notice from one part of the country to another. The government's term for this process is 'dispersal', the individual is regularly 'dispersed'.

There are many other details, where the point is precisely

the detail through which successive acts of legislation have constructed the imaginary we have come to call the hostile environment. In the 2017 Immigration Act, for example, it was legislated that a person seeking asylum was no longer allowed to drive a car. The chances of doing so were slim, but what mattered was the gesture. At every step, in each space they might be likely to occupy, it was intended that for the person seeking asylum their experience of the environment should be hostile. It was not a vague term at all, not a generalised expression of political intent, but a meticulously planned programme of alienation. The landscape through which the person seeking refuge walked was intended to be *felt* as hostile.

In the past four years, more or less since the beginning of the pandemic, the construction of the environment in immigration and asylum policymaking – whether rhetorical or legislative – has altered. In part, that re-construction is a consequence of the fact that policies of the hostile environment had become increasingly legible and therefore possible to counter at the level of analysis and action. Where previously the intention was to make the environment of the UK itself hostile – to 'create a really hostile environment' – the principal objective now is to push people away, or expel, where expel means to force out. Under the terms of the 2022 Nationality and Borders Act, reinforced by the Illegal Migration Act, it became illegal, as the Right to Remain website detailed, 'for someone who needs a visa to enter the UK to arrive in the country without one.' Since 'nationals of all refugee-producing countries must have visas to enter the UK' the intended consequence was that 'almost everyone who enters the UK to claim asylum will now technically be breaking the law, where the crime carries a maximum sentence of four years in prison.' This was coupled with the fact that the Act granted the power to treat asylum claims by people who had a 'connection' to a third country 'inadmissable'. In such cases, the Home Office is entitled to remove the person to a third country, where that

third country may not be one the person has travelled through.

There has been a change, then, in the way UK asylum policy – if it remains possible to say that there is such a thing – constructs the relation between people seeking asylum and the landscape or environment in which they are seeking refuge. The express objective is not, any longer, to create or maintain a really hostile environment for so-called illegal migration, but to expel those seeking asylum to another environment altogether.

The imperative to not expel people who are claiming asylum, to not push them back, was precisely at the core of the 1951 Refugee Convention. As that document states:

> Article 32
> Expulsion
> 1. The Contracting States shall not expel a refugee lawfully in their territory save on grounds of national security or public order.
> 2. The expulsion of such a refugee shall be only in pursuance of a decision reached in accordance with due process of law. Except where compelling reasons of national security otherwise require, the refugee shall be allowed to submit evidence to clear himself, and to appeal to and be represented for the purpose before competent authority or a person or persons specially designated by the competent authority.
>
> Article 33
> Prohibition of expulsion or return ('refoulement')
> 1. No Contracting State shall expel or return ('refouler') a refugee in any manner whatsoever to the frontiers of territories where his life or freedom would be threatened on account of his race, religion, nationality, membership of a particular social group or political opinion.

AFTERWORD

Against the principles of the 1951 Convention, the UK government is now framing policies the explicit aim of which is to expel or, more precisely, push back. The word for push back in the Convention is re-fouler, which doesn't mean 'return' exactly, but rather to force something back. It derives from Old French where it was applied to liquid and means, among other things, to push back into a channel. The fact that the principle of not pushing back is captured by the incorporation of a French word in an English language text, has the effect of drawing our attention to the importance of the term. For the authors of the 1951 Convention it was axiomatic: asylum policy must never be constructed on the basis of a relation to the environment in which people are expelled or pushed out.

The Continuing Scandal of Detention
As a practice, detention has been fundamental to the hostile environment. We could express this in many ways. On the one hand, the fact that a person can be detained or re-detained arbitrarily and indefinitely – which is to say at any moment and for any length of time – means that the environment is always at some level hostile. Where this possibility is always the case, then the environment itself will always carry some kind of threat. In another sense, however, detention is the permission the hostile environment requires. To detain a person indefinitely is to so deny their human rights as to permit other kinds of denial and mistreatment. The strongest form of this argument would be that the hostile environment requires indefinite detention because such detention creates the image of personhood on which sustained hostility depends.

At the same time, insofar as it was central to the hostile environment, indefinite detention was not difficult to argue against. Difficult to change, yes, but not difficult to oppose. The reason for this was that the hostile environment was a

picture of the UK itself, of the UK landscape, and since the UK had remained publicly committed to human rights, detention could be pointed to as an anomaly. Indeed, so anomalous had it come to seem by the end of the last decade that the law was on the brink of change. In the 2017-2019 parliament, when the government only had a narrow majority, there were sufficient government MPs embarrassed by the human rights implications of indefinite detention to ensure that, had there been a vote, the policy would have changed. But just as legislation was going through parliament, so parliament was suspended pending a general election. The vote that would have changed the law never happened.

Since that moment, the debate around detention has altered. There are various reasons for this. One is that forms of detention are proliferating. Whereas previously the detention estate consisted of between 10 and 12 purpose-built immigration removal centres so-called, now people are detained in a range of so-called 'facilities', often former military barracks, where the rules regarding their operation are unclear. The effect of this has been to blur the category, to position detention on a spectrum which could be said to include accommodation, even though that accommodation is carceral in its reality.

More generally, we are witnessing an attempt to mainstream detention as a political strategy. According to the terms of the Illegal Migration Act, detention will not be the exceptional experience – however common and frequent – of the person seeking asylum, but will be the fate of every person who, as the new legislation describes it, arrives in the country without 'legal clearance'. To repeat, under international refugee conventions, people seeking asylum are not entering the country illegally, since it is legal to seek asylum in another country. As immigration lawyers have observed, the fact that the 2023 Act makes it a criminal offence to 'arrive' in the UK without legal clearance – where the word 'arrive' has replaced

the word 'enter' – can mean that people seeking asylum are 'automatically committing an offence by setting foot on the UK mainland,' the consequence of which can be 'imprisonment'. The contradictions here are vertiginous. In effect, the person who claims their human rights at the point of arriving in the UK loses their entitlement to those rights in the act of making the claim. Detention, then, according to this narrative, is not anomalous but the generalised practice for all people looking to cross the border to request refuge. The UK government has addressed the shameful reality of what Giorgio Agamben called the state of exception by making the exceptional state of detention the political norm.

It is important to underline the logic here. Detention is being defended by being extended. As the most recent legislation has it, detention is no longer an embarrassing anomaly in the context of a country committed to human rights, but the default for the person who seeks asylum by arriving in the country via an irregular route. The real concern, in other words, for anti-detention campaigners is that detention is being further hard-wired into the political process, as a naturalised response to the person who crosses a border to seek refuge.

Calling for a Future without Detention
As the UK emerges from a general election, policymakers cannot claim that they do not know the realities of detention. In the Executive Summary of her Report following the Public Inquiry into the Mistreatment of Individuals Detained at Brook House, Kate Eves noted the findings of the *Panorama* documentary which triggered the Inquiry:

> Containing disturbing footage, the documentary portrayed Brook House as violent, dysfunctional and unsafe. It showed the use of abusive, racist and derogatory language by some staff towards those in

their care, the effects of illicit drugs, and the use of force by staff on mentally and physically unwell detained people.

The public inquiry's remit was strictly drawn; it was to consider abuses that took place at Brook House between April and October 2017, the period during which *Panorama* captured its undercover footage. But in her report, Kate Eves was careful to broaden the Inquiry's implications. As she put it, 'The issues raised are likely to have wider application.' The language is measured but what policymakers are clearly invited to understand is that this dysfunctional, abusive, racist environment, which deploys force against mentally and physically unwell detained people, is what detention becomes.

Nor can policymakers claim that they are unaware of the developmental logic of detention. If the hostile environment has taught us anything, if there is any one lesson we must carry forward, it is that once arbitrary detention is established as a political practice it is inevitable that it will extend its reach. The drive, as we have seen, is to ever more extreme, degrading, dysfunctional environments. Thus, the arbitrary and indefinite detention of people in environments modelled on Category B prisons has given way to the horrific, nineteenth-century spectre of the Bibby Stockholm barge, with the barge now a staging post for deportation to detention in Rwanda. The reason the principles of human rights exist, the reason they were codified in the period immediately following the Second World War, is precisely to prevent the development and intensification of such arbitrary and inhumane spaces. When people surrounded buses in Margate and Peckham and elsewhere, what they were clearly saying was, enough is enough. Policymakers have seen where the logic of arbitrary detention takes us. It is because the abuses of detention only intensify that detention has to stop.

And nor, now, can policymakers claim that they have not

heard directly from people who have experienced detention. Along with other groups, members of the Refugee Tales Parliamentary Self-Advocacy group have taken their stories and experiences directly to MPs. Members of the Self-Advocacy group regularly meet with parliamentarians of all parties and in the past two years, Pious Keku, Ridy Wasolua, Seth Kaitey and other members of the group have spoken at, among many other events, the parliamentary launch of the Refugees Walking Inquiry into Immigration Detention and the project's packed-out fringe meeting at Labour Party Conference. The knowledge and critical understanding that they have acquired through experience, and which they have passed on directly to people with the capacity to make change, is represented in Volume V of *Refugee Tales*. Having spoken about their experiences at public events as part of the 2023 walk, the tales and critiques they presented at those events are published here, and what we have, as across all the tales, is an account of the human cost of detention on which policymakers must now act.

Many themes come through the present volume but perhaps what comes through more emphatically than ever is the theme of waste. In 'The Leader's Tale', Osman Salih puts the question directly:

> So finally, I had been granted leave to remain in the UK. But this is my last point. If they could grant me the right to live in the UK, why did they waste my life? That is the question.

Pious Keku makes the same point in The Self-Advocate's Tale. As he puts it:

> As for my own personal experience, I waited for eleven years to be granted leave to remain. During these eleven years, I've tried everything possible to get

something done, but the authorities would not allow me to do anything.... So eleven years of my life have been wasted.

After many years, Osman Salih and Pious Keku are finally reflecting from the vantage of having secured leave to remain – that most paradoxical of phrases that carries the trace of the contradictions to which they had long been subject. K, on the other hand, is still waiting, still subject to the requirement to report and to the possibility of re-detention. As he told Guy Gunaratne:

> they tell me, Guy, if I miss even one date, don't show face, make one mistake, I will be deported... I cannot be active anymore, my body it aches, I don't even want to move. I cannot concentrate. It is really bad these days – I have never been like this before in my life.

What K repeatedly comes back to is the pressure of enduring a life that is being wasted, a pressure so overwhelming that he 'cannot be active anymore'. Seth Kaitey reports the same in The Campaigner's Tale, the short tale that concludes this volume, observing that he was subjected to detention and 'house arrest' for a total of twelve years. Unable to work, unclear whether he could volunteer, Kaitey echoes K. As he puts it, inviting us to imagine the reality: for those twelve years, entitled to do nothing, he was 'really, really under pressure'. Seth Kaitey, it might be noted, like JB, sought asylum in the UK having defended human rights in his country of origin. What he encountered instead of refuge, however, is a machinery of asylum designed to waste life.

Osman Salih's term is carefully chosen and therefore those who listen to him and read him are invited to think about it. What does it mean, the listener/reader is invited to consider to *waste* life. What does it mean to produce processes, to

construct policy environments, the purpose of which is to lay a life to *waste*. The term can pass the reader by but really it shouldn't. It should take us back to the words with which Kate Eves opened her report. Arbitrary detention underpins and reinforces the processes of the hostile environment, an environment so shameful that the fantastical intention is now to export it elsewhere. It is dysfunctional, unsafe, racist and derogatory not because some people with such views happened to find themselves in positions of authority in the same carceral space at the same time. It is dysfunctional, unsafe, racist and derogatory because it underpins a system that sets out to waste people's lives. Speaking from experience, and with all the critical precision such experience brings, Osman Salih, Pious Keku, K and Seth Kaitey set out the terms people making policy most need to hear. Pious Keku puts it this way:

> I'm calling for an end to this detention because it's having an adverse effect on humanity. We are all human. We breathe the same air that God has created. We are not different in any way.
>
> Detention is so damaging. It causes mental health problems for so many people. After detention, they have to seek counselling each and every day, each and every week, each and every month, because they just cannot cope with what they have gone through, what they went through.
>
> That is the main reason I continue to call for an end to detention.

The Walk of 2024
The Refugee Tales walk of 2024 had its start in Edenbridge, on Saturday 6 July, ending at the Houses of Parliament five days later. At Westminster, members of the Parliamentary Self-Advocacy Group met parliamentarians, the purpose of the meeting being to, once again, detail the realities of arbitrary

indefinite detention and to call for an end to this inhuman practice. One thing policymakers might want to consider is how many more times it must be reported, either by people with lived experience of detention or by those who work with them, that detention is an inherently dysfunctional, degrading, dehumanising space. In her Report on the Brook House Inquiry, Kate Eves noted a series of previous reports that had arrived at much the same conclusion, including reporting by the HM Inspectorate of Prisons, the Brook House Independent Monitoring Board and Lord Stephen Shaw's Report on the Welfare in Detention of Vulnerable Persons. As the citizens of Margate and Peckham made clear when they stopped the transportation buses, enough is enough. Enough is known about the terrible damage caused by detention. Detention has to end.

But there is something more, something larger that should be considered, and on this larger question, the French philosopher and activist Etienne Balibar has been as eloquent as anybody. Speaking in 1997 at an event organised to demonstrate solidarity with the 'Sans-Papiers of Saint-Bernard', Balibar offered a few remarks under the heading 'What We Owe the *Sans Papiers*'. 'We', in Balibar's case, meant 'French citizens of all sexes, origins and professions', and what was owed to the *Sans Papiers* followed from their political example. As he put it, by way of conclusion:

> We owe them... for having recreated citizenship among us, since the latter is not an institution nor a status, but a collective practice... They have thus contributed to giving political activity the transnational dimension that we so desperately need to open prospects for social transformation and civility in the era of globalization. For example, to start democratizing police and border institutions... They have helped us immensely, with their resistance and their imagination,

breathing life back into democracy. We owe them this recognition, we must say it, and must engage ourselves, evermore numerous, by their side, until their rights and justice are rendered.

More than ever, in the UK, as we consider the outcome of the 2024 election, we need to open, as Balibar puts it, 'prospects for social transformation and civility in the era of globalisation'. For Refugee Tales, any such transformation must start with the act of listening, with hearing the stories of people who have experienced the reality of border institutions, and in particular with that most brutal of border institutions immigration detention. The project is deeply grateful to everybody who continues to share their experience as a means of making this transformation happen and to everybody who walks to create the space in which stories can be shared. As Osman Salih puts it, at the end of 'The Leader's Tale':

> When you come to Europe, the journey is very difficult. The desert, the Mediterranean, and then finally you come to your destination, and still you have problems, and so all of this trauma, it comes to your mind. All the war, it came to me. I struggled to sleep. I spoke to my doctor, I took sleeping tablets, even with the tablets I had side effects, my body became addicted to them. Your body is tired in the morning. So why am I doing this? Why am I sharing my tale? I take you back to my claim. You need rights.

David Herd

About the Contributors

JB was granted asylum for five years in the UK. He lived in Uganda where he hopes to return one day when the dust settles. He is currently a fully qualified plumber and is training to be a gas engineer, a course he says has helped him transform into a new person, more than just an asylum seeker, and has also made him busy enough to avoid thoughts of what he went through.

Natasha Brown is a British novelist. She is the author of *Assembly* and *Universality*.

David Flusfeder's novels include *The Gift* and *John the Pupil*. His most recent book is the non-fiction *Luck: A Personal Account in 13 Investigations*.

Raga Gibreel is a journalist, a former refugee and founder of Green Kordofan, a charity providing opportunities through sports to children in Yida refugee camp in South Sudan.

Guy Gunaratne is a British novelist and playwright. Winner of the Dylan Thomas Prize, Jhalak Prize and longlisted for the Booker and Goldsmith's Prize. They are the author of two novels - *In Our Mad and Furious City* and *Mister, Mister,* - and two plays: *Ben Gvir Reads Wiesel To Mourners* and *The Life and Times of Yahya Bas*.

David Herd's collection of poetry, *Walk Song* (2022), was a Book of the Year in the *Australian Book Review* and *Writing Against Expulsion in the Post-War World: Making Space for the*

ABOUT THE CONTRIBUTORS

Human was published by OUP in 2023. He is Professor of Literature and Human Rights at the University of St Andrews and a founder and co-organiser of Refugee Tales.

Seth Kaitey lives in the North East and is currently a care worker. He has walked with Refugee Tales for nine years and introduced the Walking Inquiry to his community in Middlesbrough. He is a drummer in his local church and helps in a local foodbank.

Pious Keku is a student at Goldsmith's University, London. He is a Trustee of Gatwick Detainees Welfare Group and gives talks on behalf of the charity. In 2023 he spoke at the Cambridge Union. He has walked with Refugee Tales for nine years.

Shamshad Khan is a poet and resilience and success coach. She uses coaching and creative techniques to uplift and inspire. She has collaborated with dancers, musicians and beatboxers and is co-writer/director of the multi-media show *The Moonwatcher*. Her work was first published by Crocus, an imprint of Commonword. Her poetry collection *Megalomaniac* is published by Salt. Her poem 'Pot' is on the English GCSE syllabus. More on: shamshadkhan.co.uk

Hannah Lowe's first poetry collection *Chick* (Bloodaxe, 2013) won the 2015 Michael Murphy Memorial Prize and was shortlisted for the Forward, and Aldeburgh Best First Collection Prizes and the Seamus Heaney First Collection Prize. Her chapbooks include *The Hitcher* (2012), *R x* (2013), and *Ormonde* (2014). In September 2014, Lowe was named as one the Poetry Books Society's Next Generation poets. Her family memoir *Long Time, No See* (Periscope, 2015) featured as BBC Radio 4's *Book of the Week*. Her second poetry collection, *Chan*, also (Bloodaxe, 2016) was followed by a pamphlet *The Neighbourhood* (2019). *The Kids*, Lowe's

third full poetry collection (Bloodaxe, 2021), won the Costa Poetry Award 2021 was shortlisted for the T S Eliot Prize.

Tessa McWatt is the author of seven novels and two books for young people. Her fiction has been nominated for the *Governor General's Award, the City of Toronto Book Awards*, and the OCM Bocas Prize. She is one of the winners of the Eccles British Library Award 2018, for her memoir: Shame on Me: An Anatomy of Race and Belonging, which won the Bocas Prize for Non-Fiction 2020 and was shortlisted for the Hilary Weston Prize and the Governor General's Award. She is a Fellow of the Royal Society of Literature. She is also a librettist, and works on interdisciplinary projects and community-based life writing through *CityLife: Stories Against Loneliness*.

David Mitchell's first novel, *Ghostwritten* (1999), was awarded the *Mail on Sunday* John Llewellyn Rhys Prize and shortlisted for the Guardian First Book Award. His second, *Number9Dream*, was shortlisted for the Booker Prize and the James Tait Black Memorial Prize, and his third novel, *Cloud Atlas*, was shortlisted for six awards including the Man Booker Prize, and adapted for film in 2012. It was followed by *Black Swan Green*, shortlisted for the Costa Novel of the Year Award, and *The Thousand Autumns of Jacob De Zoet*, which was a No. 1 *Sunday Times* bestseller, and *The Bone Clocks* which won the World Fantasy Best Novel Award. All three were longlisted for the Man Booker Prize. David Mitchell's most recent novel was *Utopia Avenue* (2020).

Daljit Nagra MBE is Professor of Creative Writing at Brunel University, Chair of the Royal Society of Literature, a member of the Council of Society of Authors, a PBS New Generation Poet, and a presenter of the weekly *Poetry Extra* on Radio 4 Extra. He has published four poetry collections, all with Faber & Faber, which have won the Forward Prize for Best Individual Poem and Best First Book, the South Bank Show

ABOUT THE CONTRIBUTORS

Decibel Award and the Cholmondeley Award, and been shortlisted for the Costa Prize and twice for the TS Eliot Prize. His latest collection *indiom* is a PBS Choice.

Anna Pincus is a founder and coordinator of Refugee Tales and has worked with people in immigration detention for over fifteen years. She is currently Director of Gatwick Detainees Welfare Group.

Osman Salih lives with his mother and son in Wales. He works in building maintenance for a refugee charity. He has walked with Refugee Tales since 2016.

Scarlett Thomas was born in London in 1972. Her widely-acclaimed novels include *PopCo, The End of Mr Y* and *The Seed Collectors*. As well as writing literary fiction for adults, she has also written a literary fantasy series for children and a book about writing called *Monkeys with Typewriters*. Her work has been translated into more than 25 languages.

Ridy Wasolua is a writer, photographer, video editor and filmmaker, living with his family in London. He has worked with Refugee Tales since it began. He was detained in Colnbrook, Harmondsworth and for several years in Brook House. He is also a boxing coach who runs his own gym, 'Base Boxing', using boxing to inspire young people in his community.

Haifa Zangana is an Iraqi writer, scholar, artist and activist. She is the author of numerous books, including *Dreaming of Baghdad* (2009) and *City of Widows: an Iraqi Woman's Account of War and Resistance* (2007). She edited P*arty for Thaera; Palestinian Women Writing Life* (2017) and *Salt Journals: Tunisian Women on Political Imprisonmen*t. Haifa is currently co-editing *Overseas* featuring the winners of the International Centre for Transitional Justice writing contest.